Splash 5: Best of Watercolor
THE GLORY OF COLOR

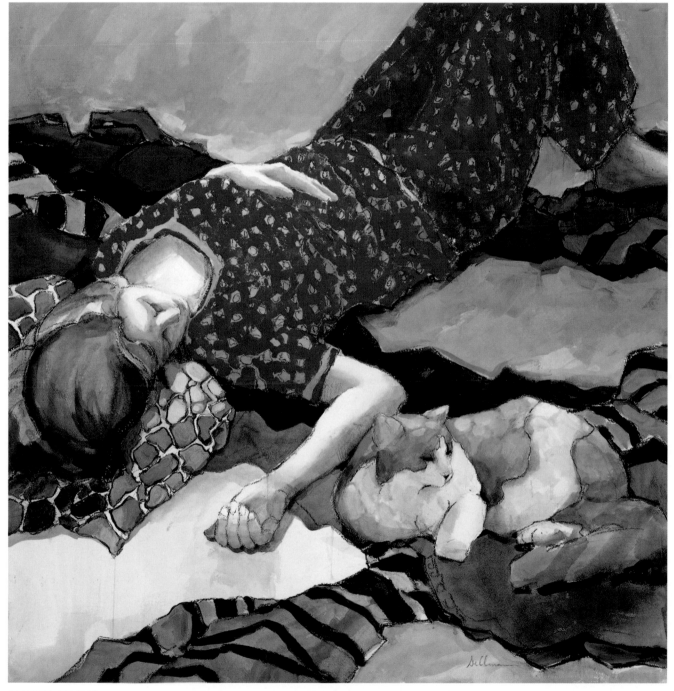

AFTERNOON NAP
Connie Dillman, 40" × 40" (101.6cm × 101.6cm)

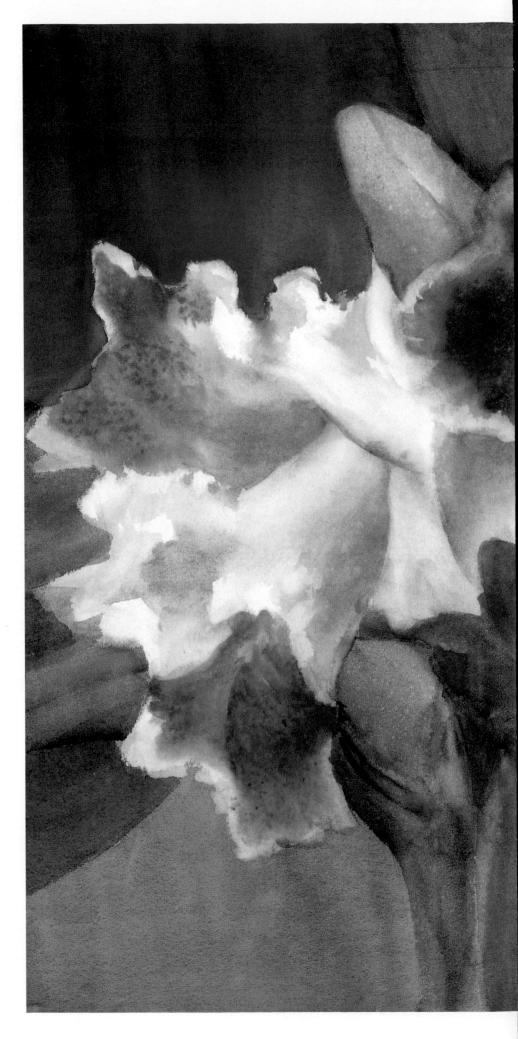

Splash 5
Best of Watercolor
THE GLORY OF COLOR

EDITED BY RACHEL RUBIN WOLF

NORTH LIGHT BOOKS
CINCINNATI, OHIO

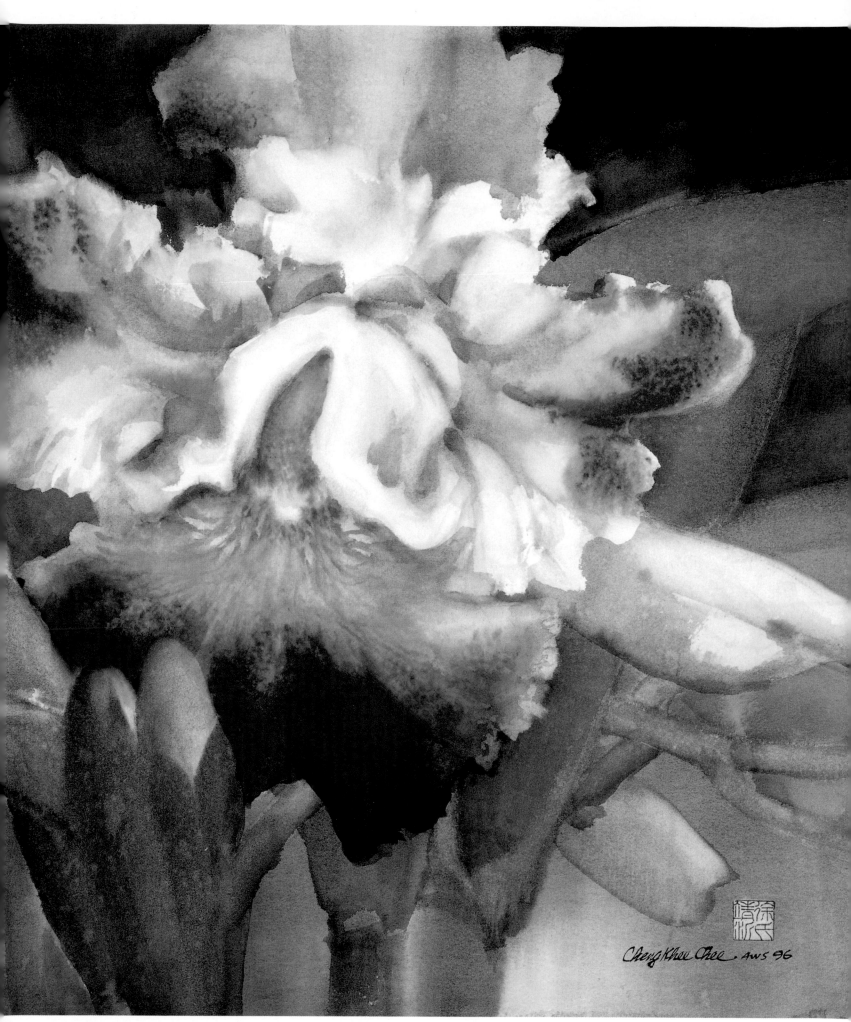

ORCHIDS
Cheng-Khee Chee, 29" × 41" (73.7cm × 104.1cm)

Rachel Rubin Wolf is a freelance writer, editor and artist. She edits fine art books for North Light Books, working with many fine artists who paint in a variety of mediums and styles. Wolf is the project editor for the previous four books in the *Splash* series and for *The Best of Wildlife Art, The Best of Portrait Painting*, and many of North Light's Basic Techniques series paperbacks. She is also the author of *The Acrylic Painter's Book of Styles and Techniques* and *Painting Ships, Shores and the Sea* (both from North Light).

Wolf studied painting and drawing at the Philadelphia College of Art (now University of the Arts) and Kansas City Art Institute, and received her B.F.A. from Temple University in Philadelphia. She continues to paint in watercolor and oils as much as time will permit. She resides in Cincinnati, Ohio, with her husband and three children.

> To the hundreds, perhaps thousands, of wonderful artists who have taken the time and effort to send us their artwork and their thoughts over the years. You have truly made our lives richer and more colorful.

Splash 5: Best of Watercolor/The Glory of Color. Published by North Light Books, an imprint of F&W Publications, Inc., 1507 Dana Avenue, Cincinnati, Ohio 45207. (800) 289-0963. First edition.

Other fine North Light Books are available from your local bookstore, art supply store or direct from the publisher.

02 01 00 99 98 5 4 3 2 1

Library of Congress Cataloging-in-Publication Data
Includes index.
1. Watercolor painting, American. 2. Watercolor painting — 20th century — United States. I. Wolf, Rachel. II. Title: Splash five.
ND 1808.S66 1990 90-7876
759.13'09'048—dc20 CIP

ISBN 0-89134-349-0 (1), ISBN 0-89134-503-5 (2), ISBN 0-89134-561-2 (3), ISBN 0-89134-677-5 (4)
ISBN 0-89134-904-9 (5)

Edited by Rachel Rubin Wolf and Jennifer Long
Production edited by Marilyn Daiker
Designed by Brian Roeth

The permissions on pages 139-142 constitute an extension of this copyright page.

ACKNOWLEDGMENTS

Thanks again, as always, to all of the wonderful editors and staff at North Light, including Jennifer Long, Marilyn Daiker, designer Brian Roeth and Tara Horton, who has a gift for keeping things organized.

MAIZE HARVEST
Jean Uhl Spicer, 14¼" × 21½" (36.2cm × 54.6cm)

TABLE OF CONTENTS

1

Energize Your Painting With

CONTRASTS *and* COMPLEMENTS *page 12*

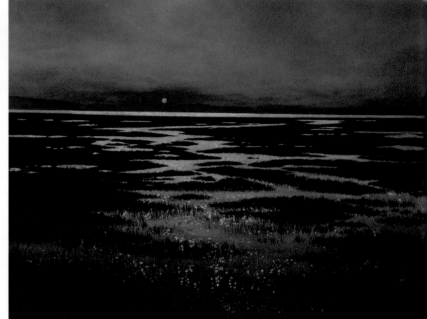

2

Personalize Color to

EXPRESS MOOD *or* INCREASE DRAMA *page 36*

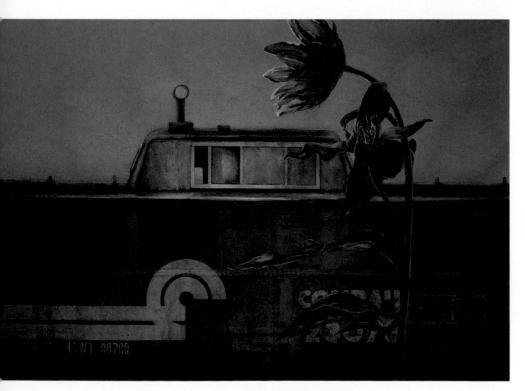

3

Communicate Meaning With

SYMBOLISM *or* COLOR SCHEMES *page 62*

When the cloud is scattered

The rainbow's glory is shed.

—Percy Bysshe Shelley

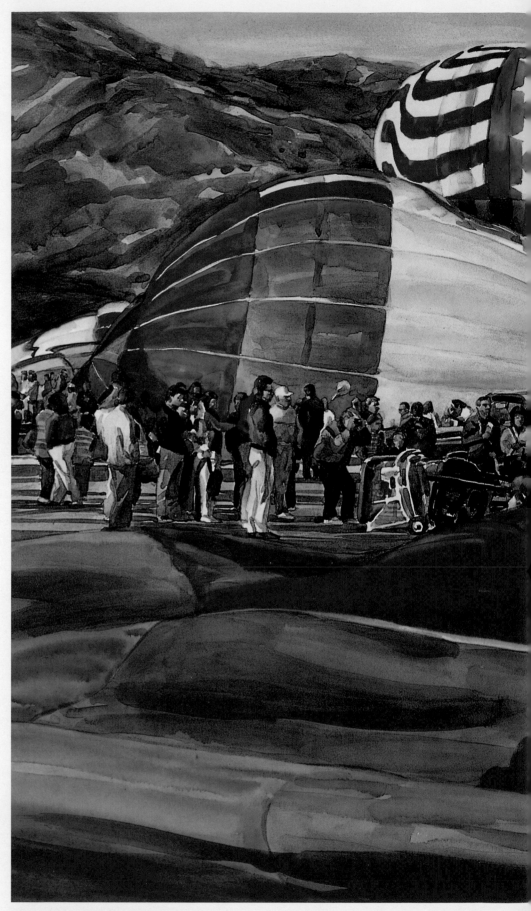

MORNING AT AUTUMN ALOFT
Gerald J. Fritzler, 18½" × 28½" (47cm × 72.4cm)

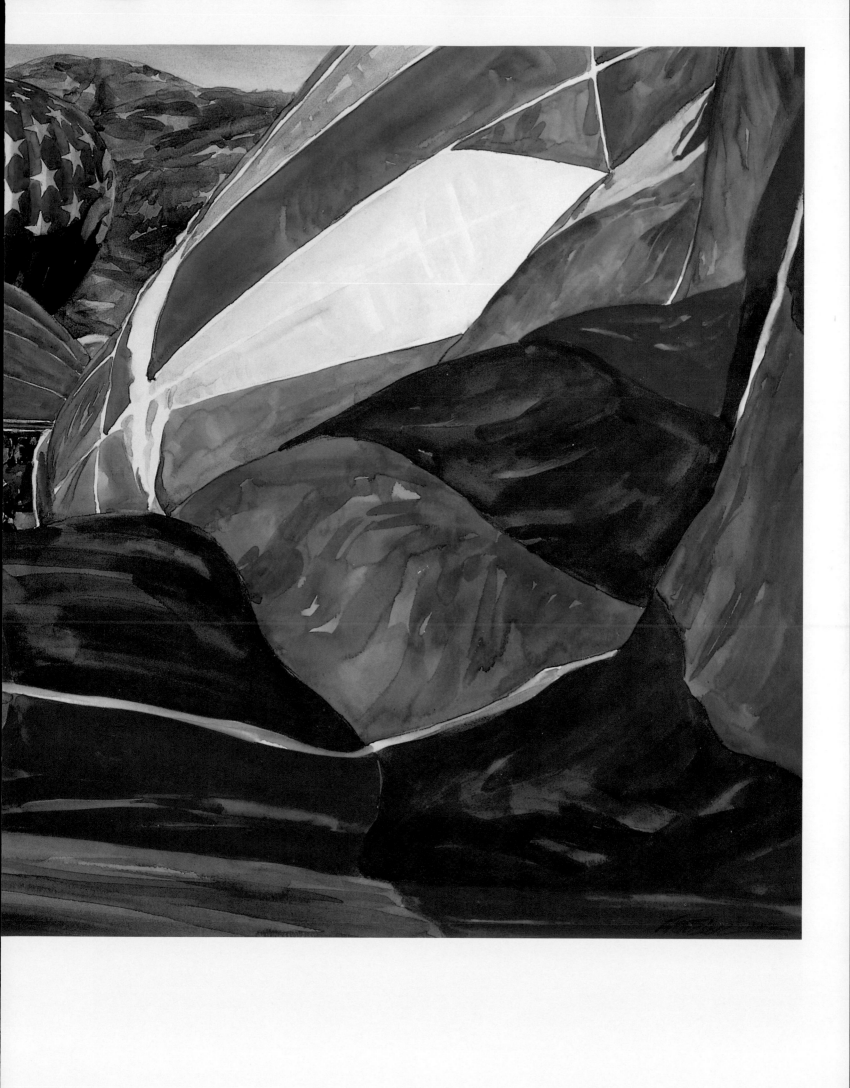

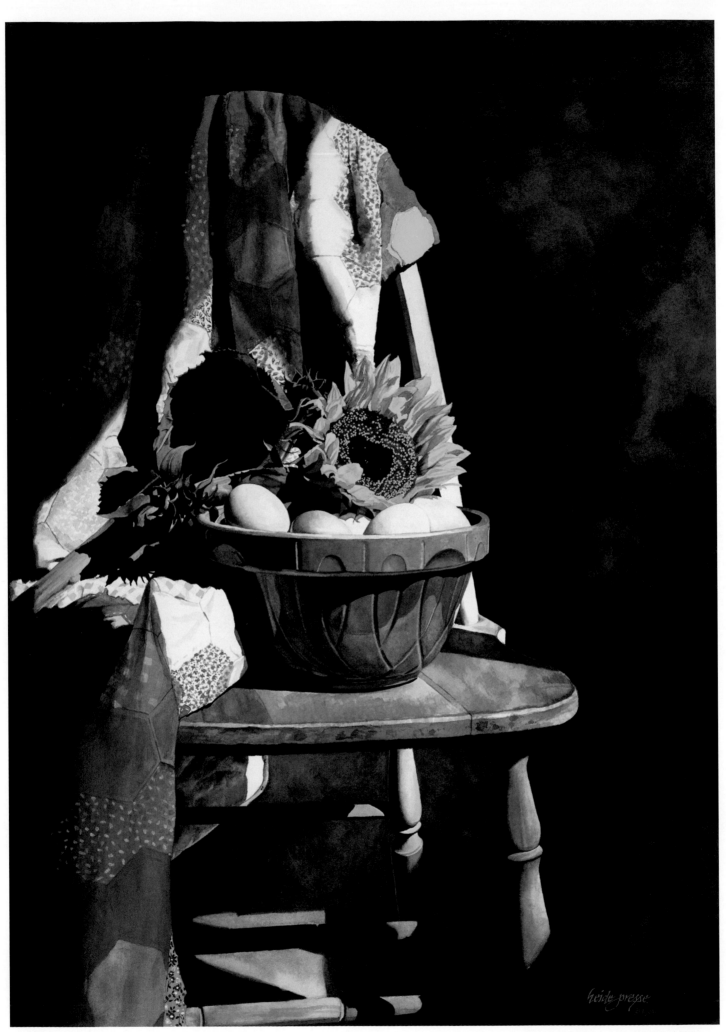

GRANDMOTHER'S FLOWER GARDEN
Heide E. Presse, 26" × 19" (66cm × 48.3cm)

Color is fun. Color is just plain gorgeous, a gourmet meal for the eye. But unlike the artist's passion for light (see *Splash 4*) our love affair with color has a lot to do with the luscious paints themselves. Haven't you ever been tempted to taste those colors because they look so delicious? Mary Gregg Byrne puts it this way, "Color for me is the most emotional and personal aspect of painting…once I start to paint I become immersed in the beauty of color revealed by light and hidden in shadows. Passion and pleasure overtake my plans."

We are inspired by the beauty and sensuality of the paints themselves, but many of the artists in this volume also talked about the inspiration they receive from nature. "Nature has a unique way of beginning and ending the day with a celebration of spectacular colors," says Robert Reynolds. Nancy Darling-Handler seeks to communicate this to her viewers: "I use color and light to awaken the viewer's consciousness to the sacred in nature and to elicit an emotional response."

We react to color, but we also desire to express the colors within. "Like emotions, colors are a reflection of life," states Janice Gennaway. Connie "Zekas" Bailey says, "Color brings excitement to a painting, whether pure and bold or through gradation. Courage to change the color of what I see to what I *want* to see enables me to aim for a bold, colorful, sparkling statement."

Whatever your own thoughts on color, both in your life and in your artwork, I hope you thoroughly enjoy this volume of *Splash*. Most of the text is filled with very practical advice on using color in your paintings—lessons you can take right into your studio. And let's remember to have fun. Consider Victoria Greene's interpretation upon seeing color break through the clouds after a storm: "Color is laughing out loud in a survival celebration."

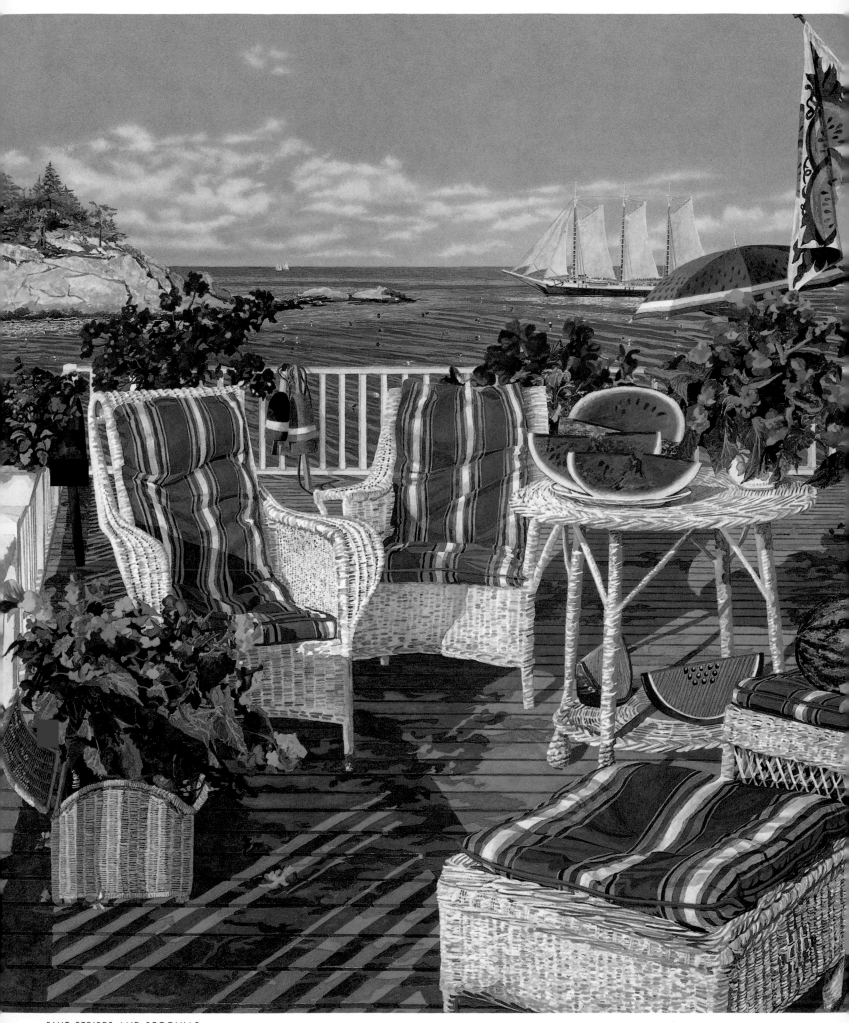

BLUE STRIPES AND BEGONIAS
John Atwater, 28⅜" × 37" (72.1cm × 94cm)

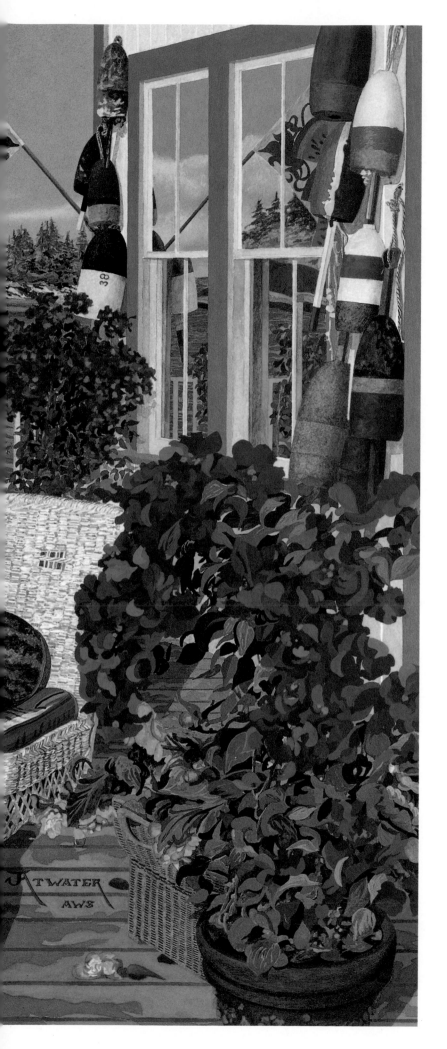

Energize Your Painting With

CONTRASTS *and* COMPLEMENTS

If you want to make your paintings hard to ignore, try increasing your contrast. There are many ways to do this, including using complementary colors and other cool/warm contrasts, using intense colors against dark values, creating texture contrasts, and creatively combining the above.

The primary focus of *Blue Stripes and Begonias* is the interplay between the bold red and deep blue colors. Though not strictly complements, the warm/cool contrast is strong. Great care was taken to subdue the blue and red hues so they would harmonize. The white areas are heavily toned with pink, peach and yellow to accentuate a warm sunlit illumination. The painting was initially completed in transparent watercolor, then at least 80 percent was overpainted with various mixtures of transparent watercolor mixed with zinc white gouache.

—JOHN ATWATER

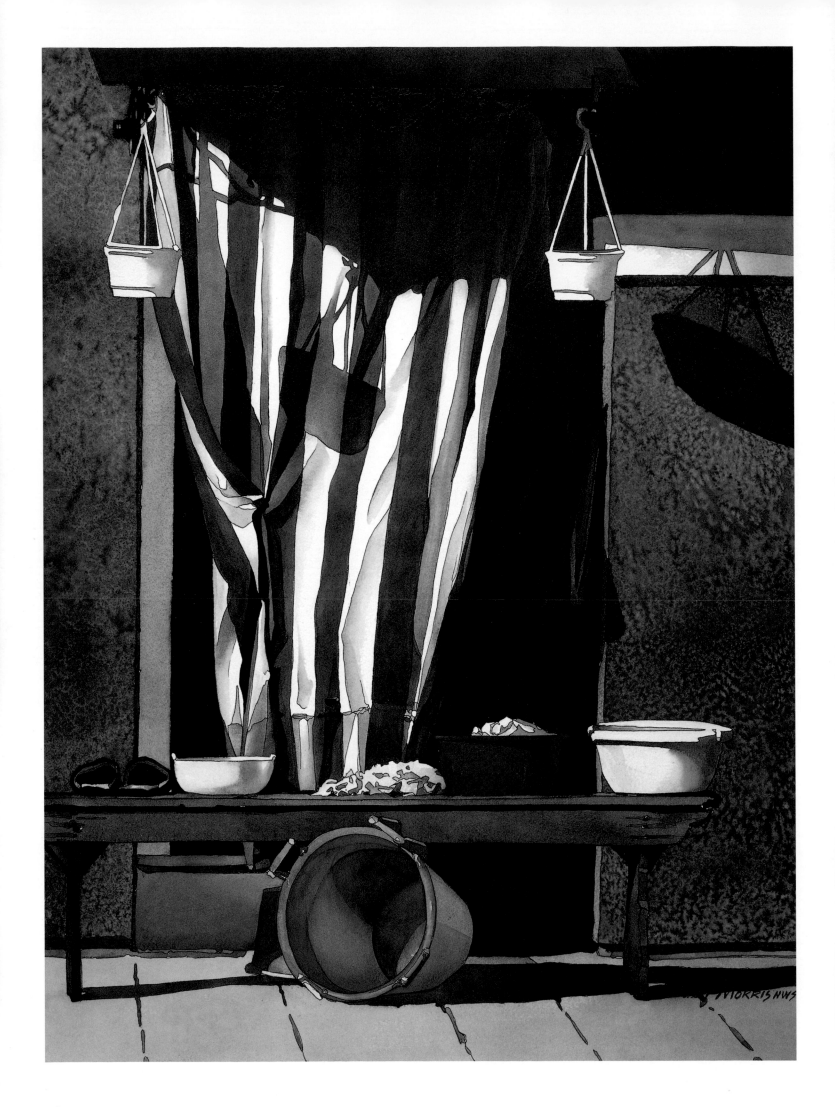

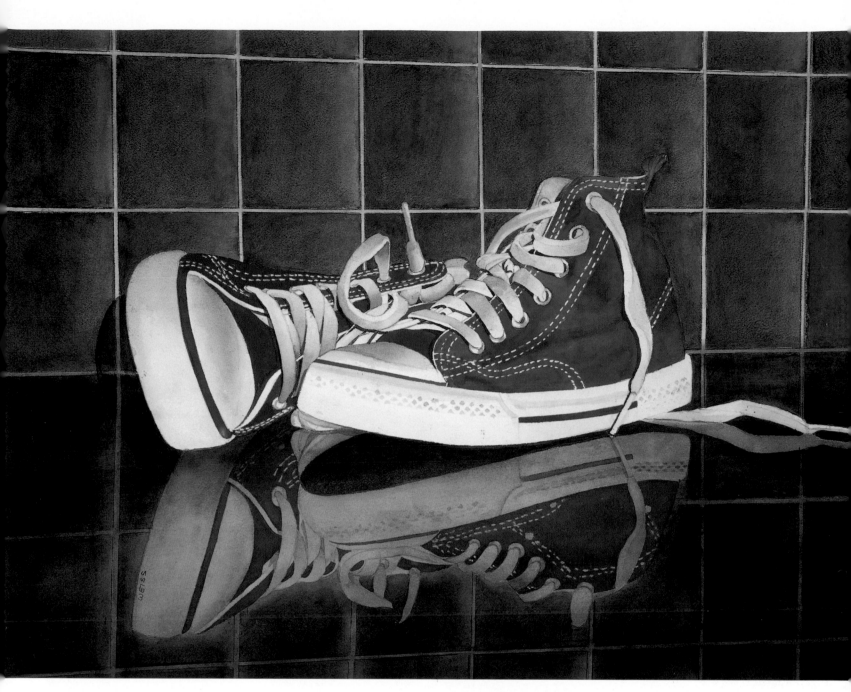

Contrasts That Can't Be Ignored

JUDY MORRIS

Few places in the world are as colorful as Burano, Italy. Residents are required to give their buildings a fresh coat of paint every year! Scenes from Burano gave me the opportunity to push color to the extreme. A red bowl, a green and white awning, a blue bucket and an orange wall create a richness that comes from using complementary colors. The bold use of color contrasts is hard to ignore. **TECHNIQUE:** Using salt to create the texture of stucco can be effective if it is tamed by layering diluted washes of pigment over the salt texture.

BELLA BURANO
Judy Morris, 29" × 22" (73.7cm × 55.9cm)

Complements Stand Out

ED WEISS

This painting is done exclusively with the complementary colors Cadmium Red Light and Winsor Green, with just a touch of Alizarin to tone down the green of the countertop and a touch of yellow in the grouting. The tennis shoes are my granddaughter's. She is eleven and seems larger than life: bright, personable, affectionate and with a limitless future. I wanted the painting of these shoes to stand out and to be "larger than life" as she is. The size of the shoes, the hues and the use of complements help attain this dramatic effect while providing the luminosity and glow only achieved with watercolor. **TECHNIQUE:** I carefully plan my paintings, draw them out completely and then paint "tightly." I go out of my way to use complementary colors, since they produce works that are pleasing and attractive.

CANDRA'S SHOES
Ed Weiss, 22" × 30" (55.9cm × 76.2cm)

Emphasize Your Focal Point With Contrast

DON DERNOVICH

I emphasized the focal point—the dead tree—by making it the lightest area of the painting. The contours are reinforced by the cool purple-blue shadow patterns laced over and across the surface of the trunk and the roots. Even after life, the tree still clings tenaciously to the water's edge.

TECHNIQUE: I broke the rules in developing *At Water's Edge* by beginning with the dark values of color to isolate and define the shapes of the stones, the tree and the foliage areas. I applied intense color directly from the tube to the rocks that were to be under the surface of the water. These rocks resembled Easter eggs until glazed over with transparent colors of Sap Green, Burnt Sienna and Winsor Blue. Rhythm and the direction of flow were indicated by the bubbles and current patterns strategically placed on the surface. I removed the shapes by cutting lightly around them with a razor blade and peeling them off after the paint had dried.

AT WATER'S EDGE
Don Dernovich
39" x 59" (99.1cm x 149.9cm)

Use a Warm Wash Under Cool Shadows

PRICKLY PEAR CREEK AFTERNOON
Loren Kovich, 18" × 30" (45.7cm × 76.2cm)

LOREN KOVICH

Early morning light hitting Montana's landscape creates spectacular visual effects with warm lights and cool shadows. To capture the overall warmth of this scene, a Raw Sienna underpainting was used in all but the sky. Glazes of purple give the rocks a luminous quality. An enticing feature of the scene was the contrast of the trees and dainty foliage against the mass and solidity of the huge boulders.

TECHNIQUE: To get the light and shadow pattern on the rocks, a Raw Sienna wash was laid down and allowed to dry. The shadows were then painted in with a mixture of Ultramarine Blue and Rose Madder. The painting was tilted so the granular quality of Ultramarine Blue would give texture to the rocks. To get the effect of reflected light on some of the rocks, Burnt Sienna was dropped into the wet purple color. Burnt Sienna pushes other colors away, creating the subtle effect of reflected light.

Orchestrate With Complementary Color Chords

JUDI BETTS

An unusual feature of *Lazy Daze* was the use of complementary colors in the underpainting. The paper was divided into four rectangles of different sizes that were each painted a different color chord. The juxtaposition of the four colors is the important element. Successive layers of paint were applied using only complementary colors to create modulation. This type of painting brings together conflicting colors harmoniously in sometimes dramatic color relationships. **TECHNIQUE:** The underpainting colors for the four rectangles were Alizarin Crimson, Cadmium Orange, Cobalt Blue and Aureolin Yellow—all in a high key. Major light areas were designed to interrupt two of the rectangles. A variety of colors complementary to the underpainting were used in each rectangle, allowing them to bleed along the borders. Darks were layered with pure color.

LAZY DAZE
Judi Betts, 22" × 30" (55.9cm × 76.2cm)

Give Complements a Place to Rest

DIANE PETERSEN

When I began this painting, I knew I wanted to capture the intense Wisconsin color. I decided to keep the shapes simple and relatively flat. The grays in the smaller building serve as the middle value so that the strong complement of red and green have a place to rest. Painting around the wonderful whites, I kept the pigment loose and alive, mixing it mostly on the brush, painting quickly. **TECHNIQUE:** I recently changed to Daniel Smith watercolors and my new palette has forced me to break old, comfortable habits. More of these watercolors are transparent and permanent, and the colors are pure and intense.

WISCONSIN CONCERTO
Diane Petersen, 22" × 16" (55.9cm × 40.6cm)

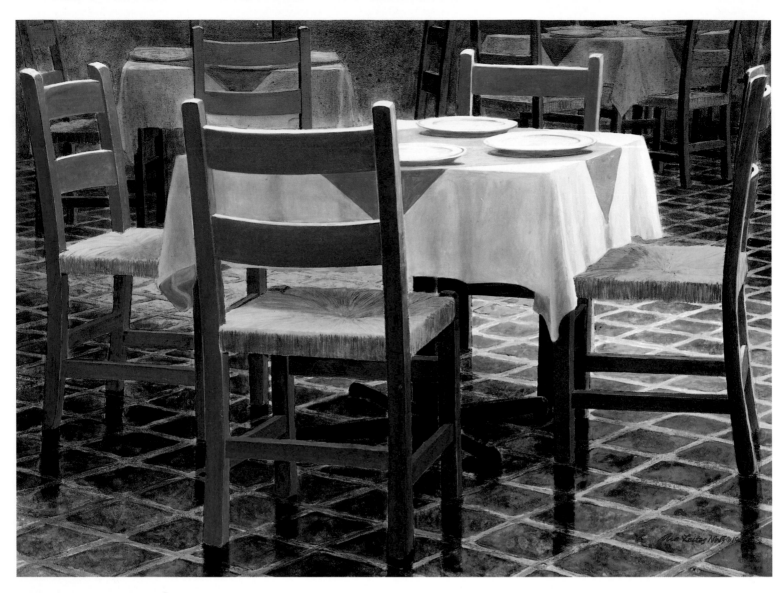

Try a Two-Color Complementary Palette

ARA (BARBARA) LEITES

This composition utilizes a limited palette of the color complements Cobalt Blue and Burnt Sienna. The largest area of pure Cobalt—the foreground chair—is also the largest dark, and the nearest object. This becomes the principle player in the composition. The use of a limited palette of two-color complements like Cobalt Blue and Burnt Sienna can provide control of the picture plane space, set the mood, confirm the content and make available a full range of colorful grays when mixed together.

TECHNIQUE: Some other techniques used were alcohol resist for textural contrast on the floor, a final glaze of neutral gray over the background area for additional depth and limiting the use of pure Cobalt to the foreground chair.

SETTING UP
Ara (Barbara) Leites, 22" × 30" (55.9cm × 76.2cm)

Set Up Multiple Contrasts

JUDY MORRIS

The combination of intense color and strong value with complementary and texture contrasts builds surface richness in this interpretation of a window in Ajijic, Mexico. The neglected state of the crumbling stucco wall is in sharp contrast to the smoothness of the sky. The flowers in the window contradict the feeling of neglect. The dark shadows suggest bright sunlight. The combination of so many strong contrasts sets the stage for a painting where color is used with confidence. **TECHNIQUE:** You can imitate the texture of crumbling stucco by sprinkling salt into painted areas that are still wet. Different salts and pigments provide a wide variety of "texture" possibilities.

EL CIELO AZUL
Judy Morris, 28" × 20½" (71.1cm × 52.1cm)

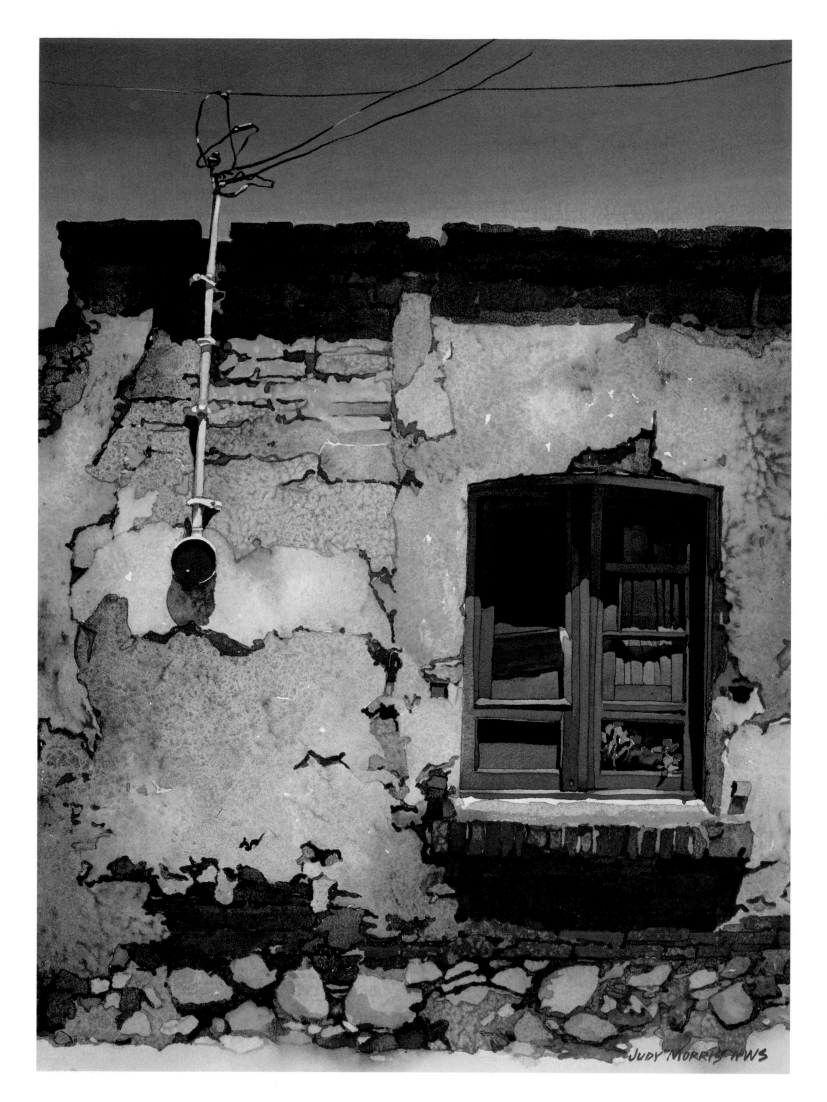

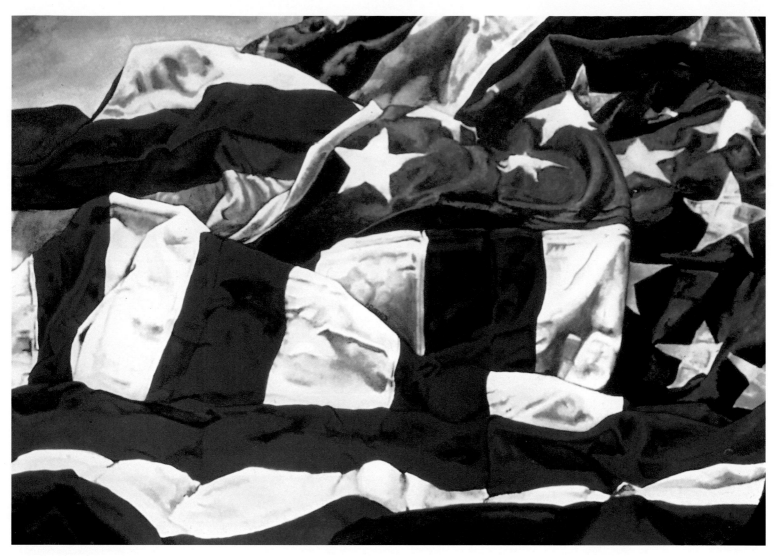

Contrast Cools and Warms for Depth

TO LIFE
Caroline A. Doucette, 14½" × 21¾" (36.8cm × 55.3cm)

CAROLINE A. DOUCETTE

The flags in *To Life* get their depth from the use of cools and warms. **TECHNIQUE:**
I used Cadmium Red (warm) and Alizarin Crimson (cool) to make the basic color
of the red stripes. As the stripes move away from the viewer, the Alizarin Crimson
dominates, cooling them. As the stripes come forward, the warm Cadmium Red
becomes dominant. The bottom, closest stripe is actually Cadmium Red and New
Gamboge. The color looked quite orange when I mixed it, but in the completed
picture all the mind sees is a red stripe that comes right out of the picture and gives
the painting depth.

Contrast Two Sets of Complements

KAREN FREY

The concept for this painting originated during a walk through my neighborhood. The long, cool shadows of the late autumn afternoon, the funky character of the cars and the interesting perspective attracted me. I sensed two sets of complementary colors: red/green and purple/yellow. I decided the red car/green car contrast would dominate the composition. Therefore those color elements are more saturated. The second complementary set, purple and yellow, establishes the majority of the painted surface: street, cast shadows, distant buildings and cars. In these areas I subdued the colors in more diluted washes so they would support, not compete with, the red car/green car exchange. **TECHNIQUE:** As I develop a painting, I repeatedly use the same color ingredients, altering the recipes. This enables me to maintain consistent color harmony.

RED CAR—GREEN CAR
Karen Frey, 19" × 25" (48.3cm × 63.5cm)

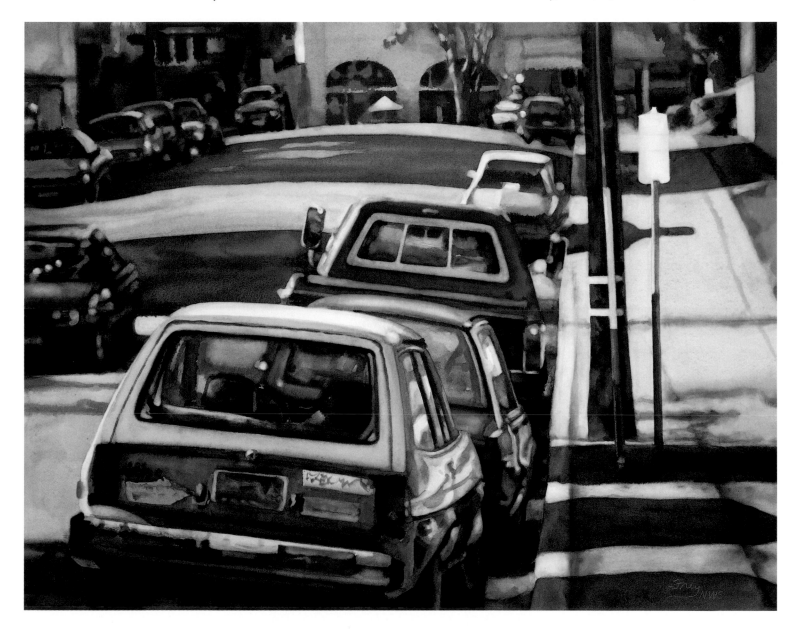

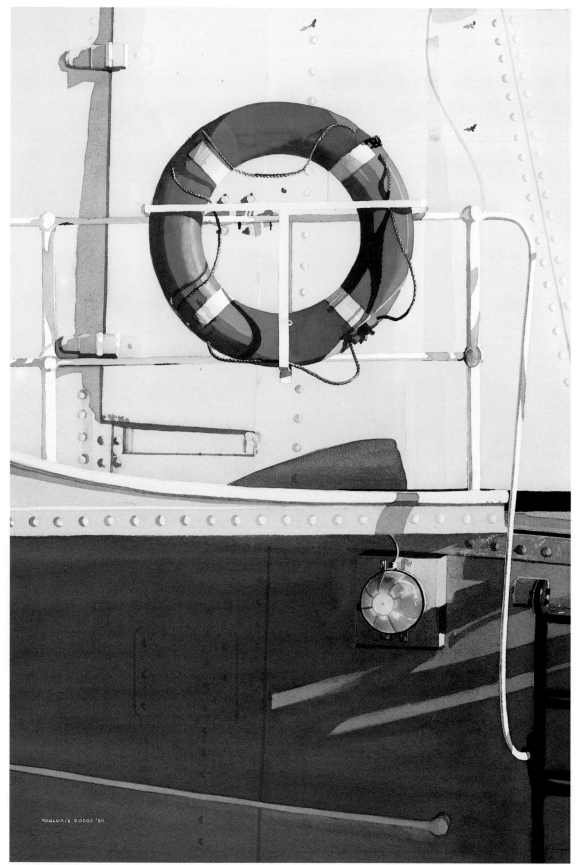

HARBOR LIGHT,
STOCKHOLM, '96
Linda Kooluris Dobbs
28" X 18¾"
(71.1cm X 47.6cm)

Complement Adds Energy to a Structured Design

LINDA KOOLURIS DOBBS

In Stockholm, after a long day's walk, I returned to the dock at Nybroviken to gaze at a favorite ship in late afternoon light. The ship's colors are in the analogous range: yellow-green, green, blue-green. The structured composition is made more dynamic by the use of diagonal lines and the complementary soft orange in the life preserver. **TECHNIQUE:** To represent the end of the day, the edges between the bright areas and the shadows must be kept soft, either by keeping the values close or by blending the edges where the two colors meet.

Place High-Intensity Colors Next to Darks

LINDA KOOLURIS DOBBS

Twice around the island of Isla Mujeres, Mexico, at golf-cart speed, I searched for images to paint. Here one is constantly aware of high-intensity colors placed against dark colors. In this rather formal composition, the midday shadows on the ground are short and the tropically lit colors brilliant. The edges around most forms are kept quite sharp by extremely contrasted values. **TECHNIQUE:** When the painting was basically finished, I cleaned up the line of the column and built up the radiance of the bougainvillea with acrylic, always remembering that acrylic appears much darker dry than wet.

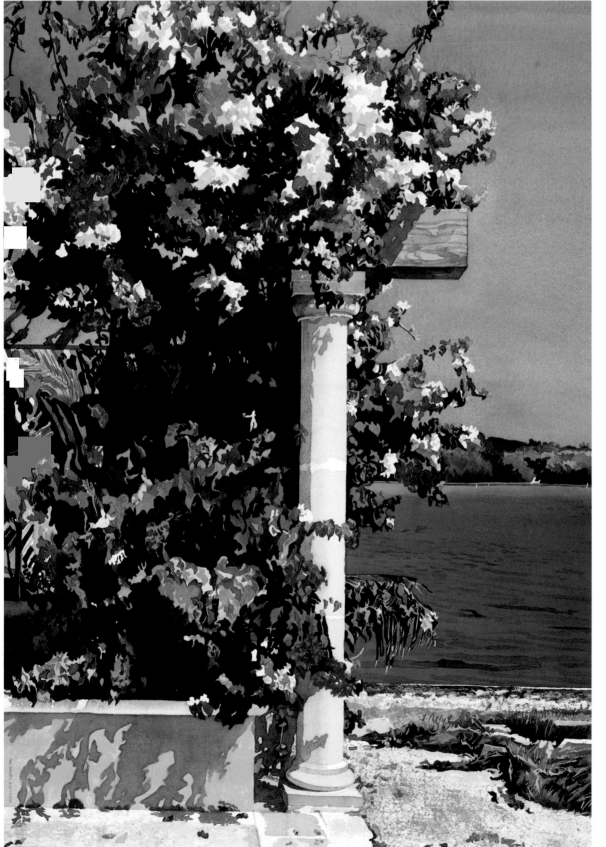

COLUMN WITH FLOWERS,
ISLA MUJERES, '96
Linda Kooluris Dobbs
28" X 19" (71.1cm X 48.3cm)

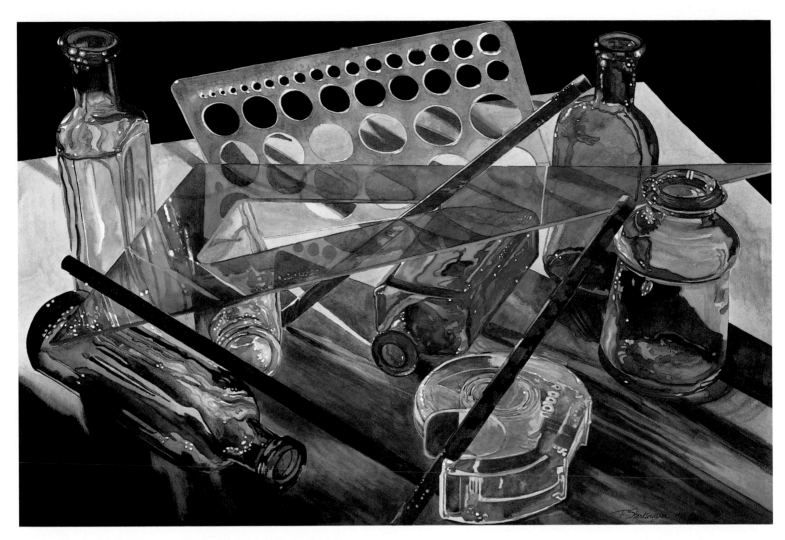

Use Complements With Varied Values and Intensity

TERI STARKWEATHER

All three basic complementary color combinations (red/green, blue/orange and yellow/violet) are used in this painting. The combinations are varied by using a vivid version of one color and a muted, less intense tone of the other. The intense yellow of the tape dispenser contrasts with the more subdued lavender bottle. The deep, rich blues of the bottles are set against the muted orange in the shadow on the table top. The light green of the circle guide and the deep emerald green of the bottle are complemented by the bright pink of the triangle, pink being a derivative of red. **TECHNIQUE:** The grays were all achieved by mixing complements, but the black background was painted with Winsor & Newton Designer's Color Black. Designer's colors cover large dark areas without streaking. The highlights were achieved by painting around the white of the paper.

GEOMETRIC ROMANCE
Teri Starkweather, 30" X 40" (76.2cm X 101.6cm)

Try Low-Key Value Complements

LESLIE RHAE BARBER

In this painting, I was drawn to the wide range of value and complementary colors. The image contained deep greens against translucent reds, saturated darks against soft, muted pastels, and most intriguing, the splash of blue in one goblet set off by the intensity of red-orange reflections in the glass and background. **TECHNIQUE:** The darks were created by mixing staining pigments, such as Winsor Green, Permanent Alizarin Crimson, Winsor Violet, Winsor Blue and Burnt Sienna. Color intensity was achieved by using pigment with just enough water added to allow the paint to spread.

LE SOLEIL, LES RAISINS...
Leslie Rhae Barber, 20" X 13¾" (50.8cm X 34.9cm)

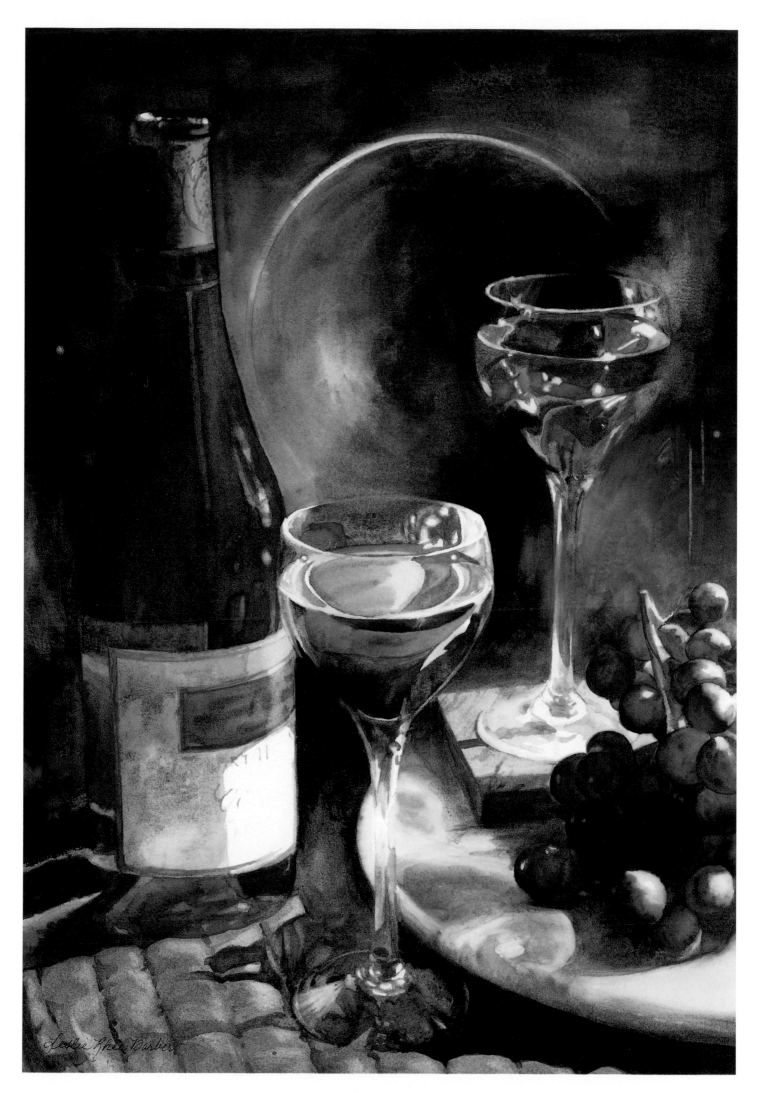

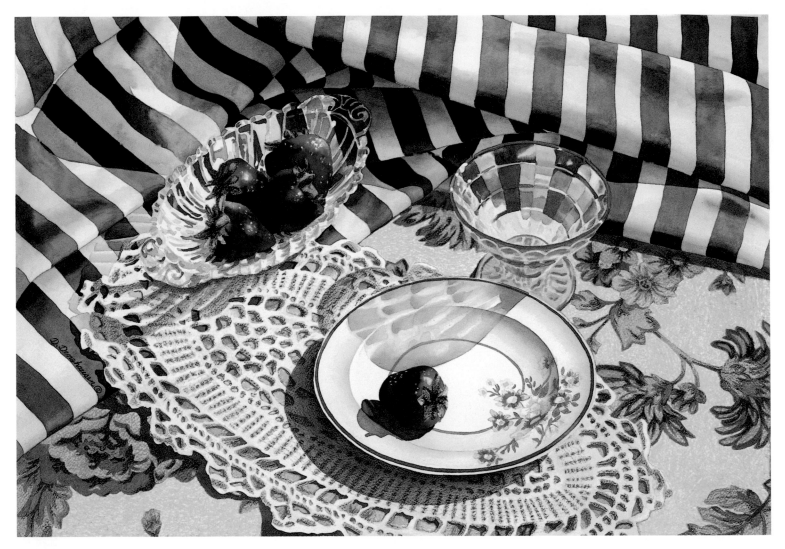

White Patterns for a Crisp, Clean Look

STRAWBERRIES AND STRIPES
D. Denghausen, 13" × 17" (33cm × 43.2cm)

D. DENGHAUSEN

In *Strawberries and Stripes*, I wanted the viewer to feel the warmth of the morning sun as it reflects through the delicate glassware, so I used warmer yellows and reds. Contrast that with the cooler blues in the striped fabric and shadows and the mood is set. The strong patterns of white are planned in advance and help give this painting a crisp, clean look. With patience and control, I paint using many layers of glazes. **TECHNIQUE:** Once the watercolor is complete, I go back into weak areas with a wax-based colored pencil to enrich colors or add texture. Remember that the wax acts as a resist, so you can't go back in with watercolor again. In this piece, I drew over the flowered fabric, brightening it and contrasting its texture with the striped material. I repeated the pencil in the stems for added interest.

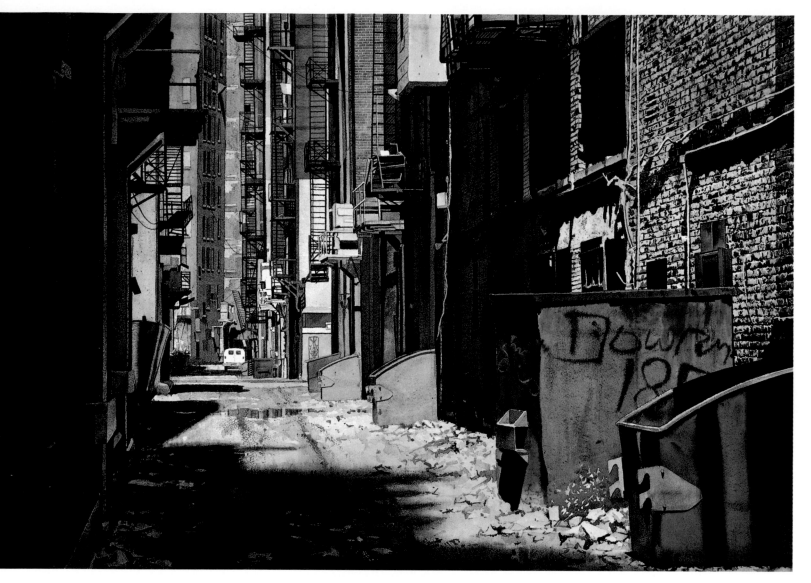

ALLEY IN DETROIT
Scott Hartley, 30" × 40" (76.2cm × 101.6cm)

Balance Strong Contrasts

SCOTT HARTLEY

Strong movement into deep space is enhanced by the movement of colors from foreground to background, high to low and side to side. The dancing colors and plethora of detail are held in place by a very simple, strong, yet delicately balanced light and dark pattern. Pools of rich, dark, mysterious color lurk in the shadows while the lights in their random assortments vie for the viewer's attention.

TECHNIQUE: While I keep my initial visual excitement in mind, I do my "homework"—that is the manipulating and designing stage, the shifting, cropping, testing, leaving out, putting back in, looking in the mirror backwards and upside down, hair-splitting, hair-pulling stage—until I feel as though I have achieved a sensitive harmony between the main shapes in that rectangle. Then I hang a value on each of those shapes so that there are at least three main tones. Finally I get to think about color. It will work now because I established a framework to put it on. I borrow the colors from the photo, but I alter them so they say what I want them to. Balance is my goal, among colors, values and structures, to the end that I capture that subtle aura that first intrigued me.

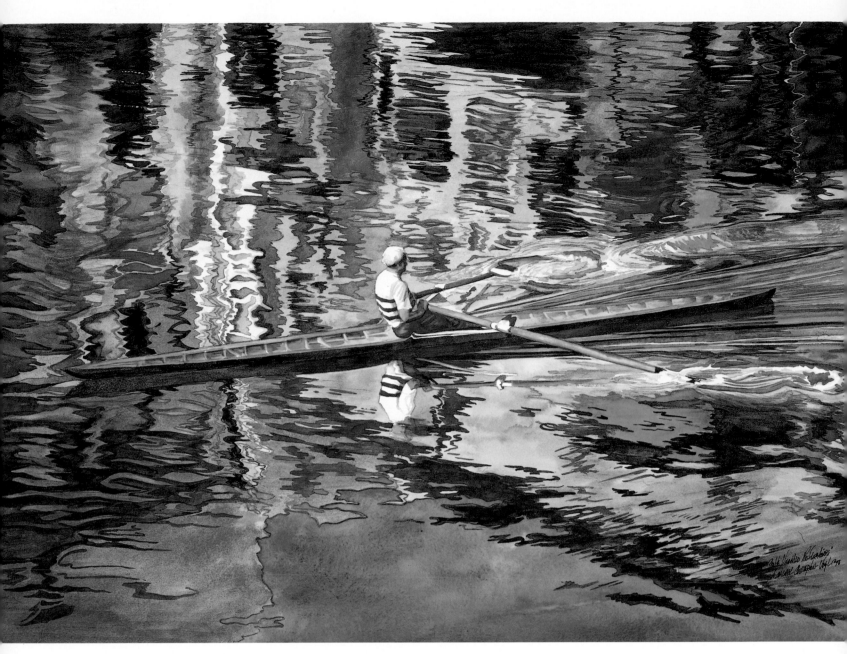

Intensify Your Colors to Make Them Vibrate

LAUREL COVINGTON-VOGL

On a visit to Italy I photographed a number of sites to use as reference material. The Ponte Vecchio bridge over the Arno River in Florence has a variety of orange and terra cotta colors that make it an intriguing subject. I was experimenting with close-ups while trying for an unusual view of Ponte Vecchio. Suddenly I was aware of the scull on the river. I shot it as it crossed and rippled the reflection of the bridge, creating the unique composition and vibrating color scheme I wanted.

TECHNIQUE: I worked on the painting upside down while defining the shapes of the rippled bridge reflection. The oranges and red-oranges in the reflection were intensified to provide a complement to the blues and blue-greens in the water. Mixes of Manganese Blue and Prussian Blue create the shimmering depth in the water.

PONTE VECCHIO REFLECTIONS
Laurel Covington-Vogl, 18" X 25" (45.7cm X 63.5cm)

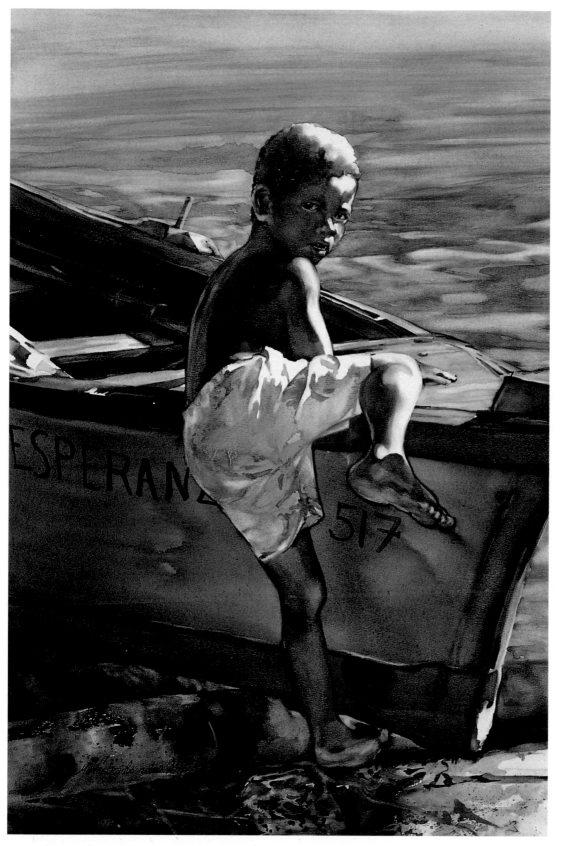

Grab Attention With Vivid Contrasts

MARLENE A. BOONSTRA

After a long, gray, Midwest winter, the vibrant colors of the Dominican Republic were a welcome sight. The impact of a painting is also often related to color. Color grabs attention and says, "Hey, look at me!" I wanted people to see this humble village boy—living on hope and handouts—as vividly as he appeared to me. **TECHNIQUE:** This painting was done on Crescent #114 cold-press watercolor board, with Thalo Blue and Green watercolors. The board allows for lifting color with a stiff bristle brush to produce soft highlights. Because it absorbs little of the paint it retains all of the vibrancy of color after drying.

A Vibrant Color Stimulates Curiosity

KATHLEEN BRENNAN

I love to explore the harmonics of complementary colors. Blue and orange are a favorite combination. I was particularly drawn to the vibrant orange rocks in this painting because they seemed to glow in the late afternoon light and made me wonder what might be further upstream. **TECHNIQUE:** I began with a textured "pour" of Indigo, Antelope, Scarlet and Daffodil FW acrylic inks. The suggestion of foliage in the background encouraged me to develop the stream image. Rocks were established with watercolor washes over the inks, and the stream was painted with white ink.

MYSTERIES UPSTREAM
Kathleen Brennan, 22" × 30" (55.9cm × 76.2cm)

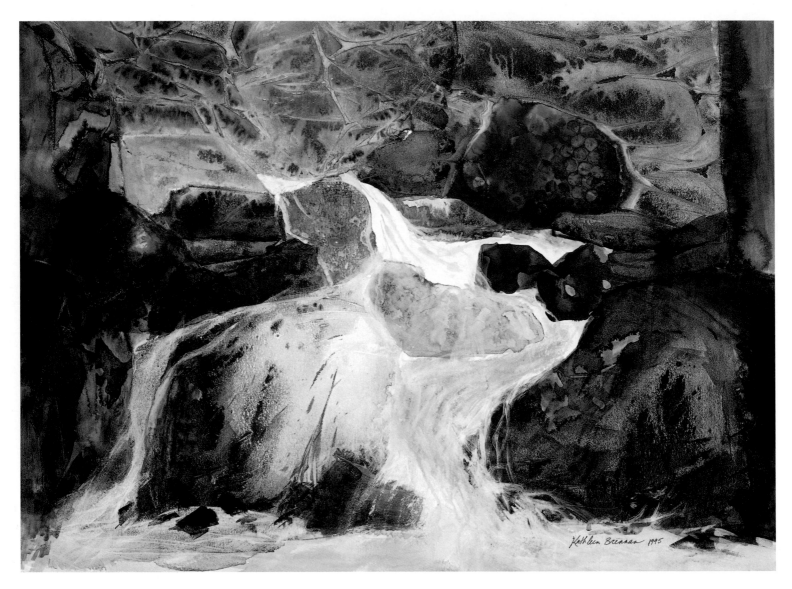

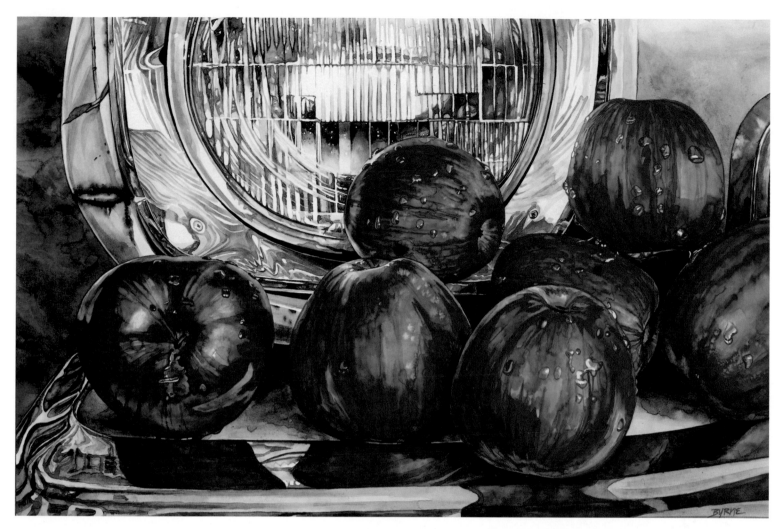

APPLES ON AN OLD CAR
Mary Gregg Byrne, 20" × 29" (50.8cm × 73.7cm)

Contrast Unexpected Companions

MARY GREGG BYRNE

Surprisingly, this painting was a found composition. Walking in my neighborhood, I found an old car on which some good genius had set windfall apples along the bumper. I love to paint reflections and transparency, so the chrome and glass contrasting with the bright apples attracted me. Diffuse light from our overcast Northwest weather created rich, saturated colors. **TECHNIQUE:** This work was painted on Crescent hot-press watercolor board. I like this surface because it doesn't tolerate overwork. I paint boldly with minimal layering, so that the color stays fresh. Much of this painting was done wet into wet. I used salt sprinkles to make patterns of color on the apples, but tried not to be too obvious about it.

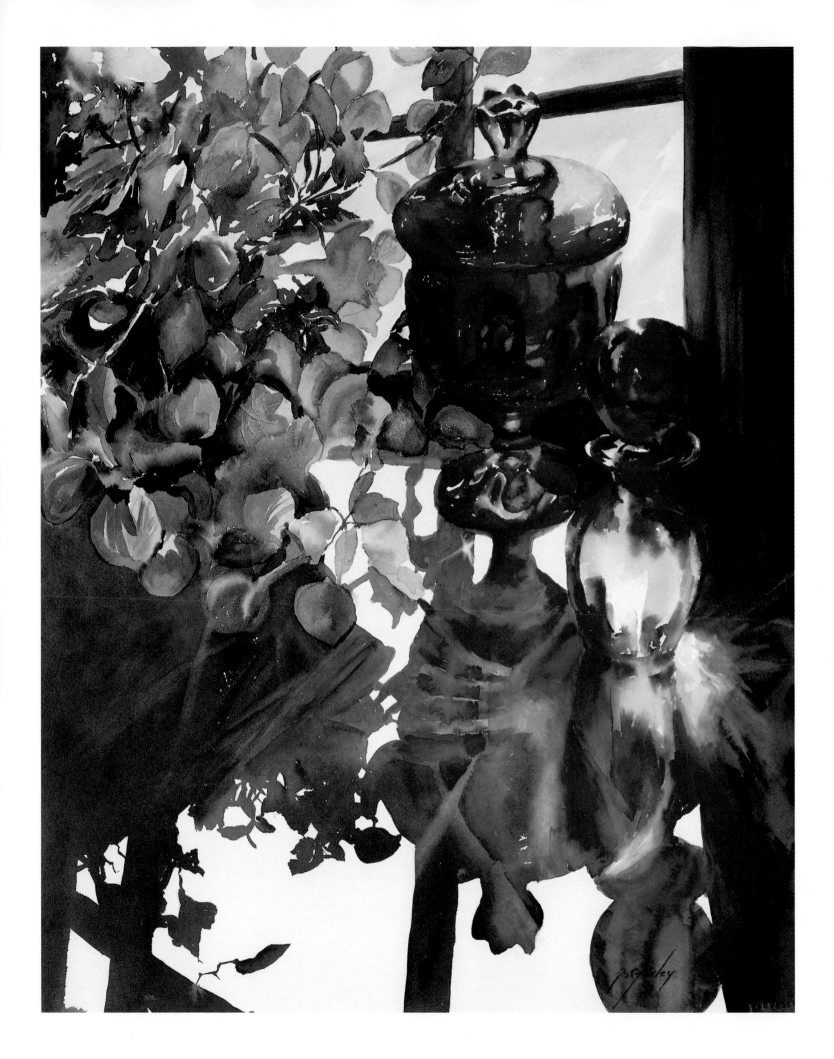

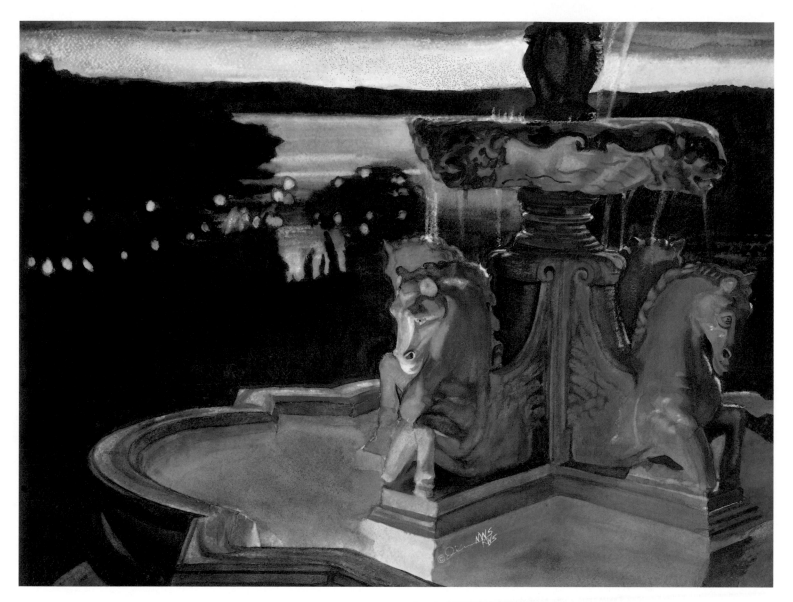

Contrast Potent Colors With Soft Colors

HENRY W. DIXON

In this painting, my intent was to highlight the very potent and fluorescent-like colors of the illuminated fountain against the soft, pastel-like colors of a typical sunset on Tablerock Lake in Missouri's Ozarks. I like to use contrasting elements and/or situations to highlight or diffuse color. **TECHNIQUE:** My technique of using very dark areas and shadows to surround and intensify or highlight colors has been used for centuries. I also employ the white of the paper to intensify the colors.

NIGHT VISION IV—TABLEROCK LAKE
Henry W. Dixon, 18¼" × 24½" (46.4cm × 62.2cm)

Complements Can't Share Equal Dominance

BETTY GANLEY

Mom's collection of colored glass has always adorned her favorite bay window. When the light is just right, colorful prisms dance all over the room. The backlit pieces of glassware create dynamic reflections and color-filled shadows. The negative spaces become abstract patterns. **TECHNIQUE:** Complementary colors shouldn't share equal dominance. With the use of such brilliant reds, the complementary color (green) had to be subdued. This is done by adding a slight bit of red to the green mixture. Using the same colors throughout the painting unifies it, so the same reds that were used in the shadowed areas were added to the green leaves.

PRISMS
Betty Ganley, 24⁹⁄₁₆" × 19¼" (62.3cm × 48.9cm)

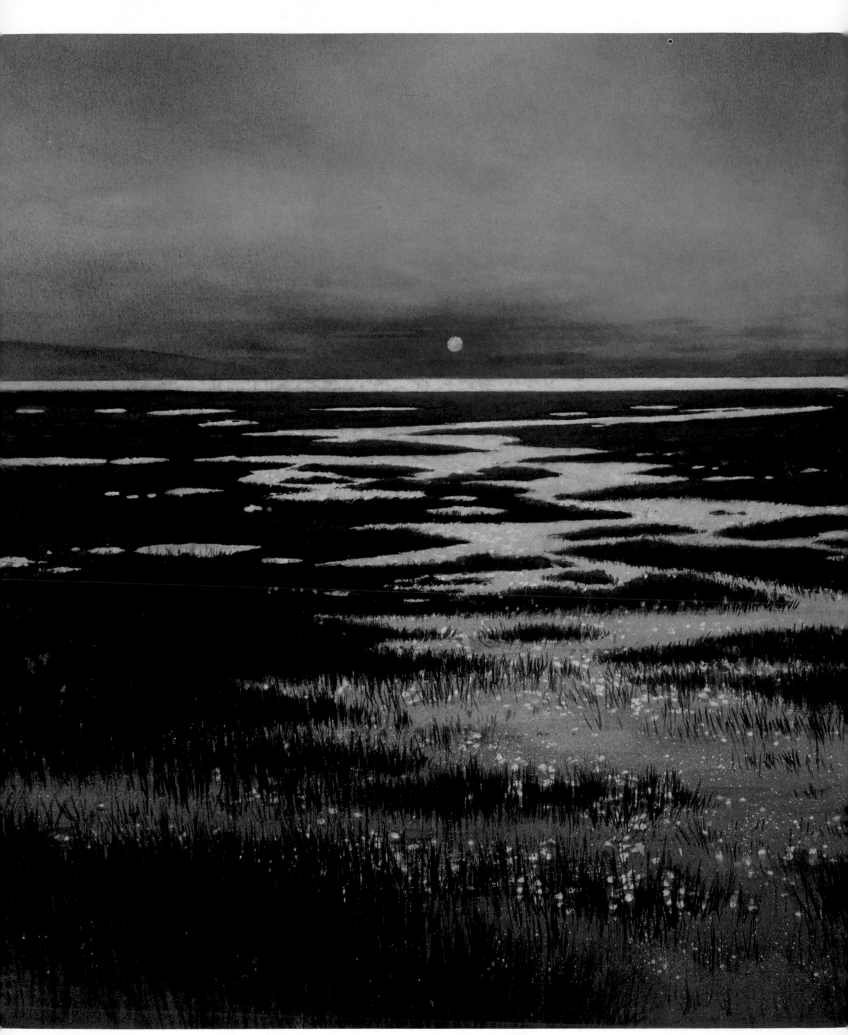

ESTUARY GLOW
Robert Reynolds, 21" × 27" (53.3cm × 68.6cm)

Personalize Color to

EXPRESS MOOD
or INCREASE
DRAMA

Color is one of the most potent tools for creating mood in your painting, whether it's expressing the feeling of a particular city, a sense of whimsy or enhancing the spirituality of an image. In the same way, visual impact can be increased by the wise use of color, whether that color reproduces a dramatic event of nature or comes from the artist's imagination.

If *light* is the spiritual quality of a painting, *color* is surely its heart and passion. Ironically, the myriad combination of colors that the human mind can conjure up pales next to what nature can repeatedly create on a daily basis. *Estuary Glow* was mostly painted from the memory of countless sunsets at this particular coastal location near my home. The drama of a sunset creates a fleeting mood in a moment in time; it won't occur exactly the same way again. This is also true of the spontaneous and elusive quality of watercolor. Watercolor and nature make for an exciting alliance.

—ROBERT REYNOLDS

White Gouache Enhances Night Glow

JILL FIGLER

Sam Wo is one of a series inspired by San Francisco's China Town. I was intrigued by the effects of the neon light. To heighten the drama of the night scene, I incorporated both transparent and opaque colors. I kept the center of interest very transparent, and as I moved into the background, I added white gouache to my palette to gray the colors. **TECHNIQUE:** White gouache was added to my transparent palette of French Ultramarine Blue, Permanent Rose and Winsor Green. This helped to enhance the night glow. By adding the opaque colors Cadmium Orange, Burnt Sienna and Lemon Yellow, I was also able to exaggerate the strong contrasts.

SAM WO
Jill Figler, 22" × 30" (55.9cm × 76.2cm)

SHOE MENAGERIE
Janice Gennaway, 19" × 27" (48.3cm × 68.6cm)

Primary Colors Reflect Playfulness

JANICE GENNAWAY

Color is an emotional and compositional tool. In this painting, I wanted to reflect a childlike emotion of playfulness, so I used mostly primary colors, as if the shoes were crayons or toys. As the title states, I don't just think of shoes as shoes, but as animal-like creatures that reflect different characteristics of the people who wear them. The different colors represent these emotional traits and give the painting its human presence.

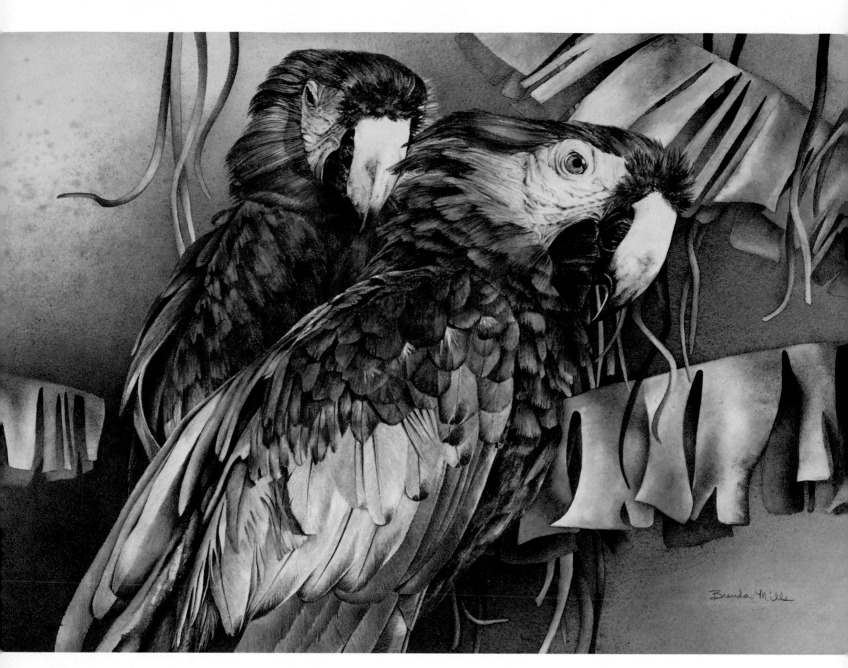

Harnessing the Power of Red

BRENDA MILLS

LADIES IN RED
Brenda Mills, 16" × 23" (40.6cm × 58.4cm)

I encountered these scarlet macaws while traveling through Mexico, and knew I had to paint them. I am completely obsessed with the patterns, textures and particularly colors I experience by getting close to nature. When I spotted this bonded pair of scarlets in a cage in someone's yard, I lingered to sketch and noticed my mood shift. Red excites me. Red is a powerful color that stimulates the viewer both emotionally and physically. I wanted to convey the brilliant red and yellow of these birds without allowing the color to overpower the softness of their feathers or the intricate pattern of their connected pose. **TECHNIQUE:** To quiet the loudness of the strong colors, a layering technique was used. Darkening the warm reds or blues would have resulted in dull colors. Instead, I layered the color in a dry-brush method, preserving the purity and brilliance. The background was painted very wet with minimal color and texture, allowing the focus to remain on the subject.

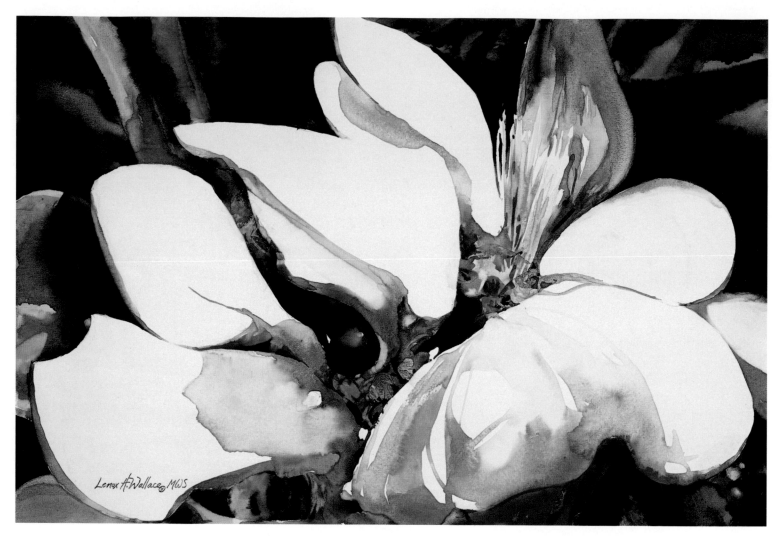

BLOSSOM
Lenox H. Wallace, 20" × 30" (50.8cm × 76.2cm)

High-Value Contrasts Increase Impact

LENOX H. WALLACE

Planning for good design and composition comes first. But I also try to anticipate the individual nature of specific colors, including their color temperature, complements and their staining or sedimentary qualities. Because increased value contrasts heighten color impact, I use intense color and strong values. But the richest color and vibrancy seem to occur when there is a sense of playfulness on my part. This dance of watercolor painting is a very active, flowing, kinesthetic partnership.

TECHNIQUE: Experiments on canvas have energized my work recently. This is such a piece. In this painting, I enlarged a very small portion of a larger composition in an attempt to heighten the abstract quality and challenge my ability to let paint be paint.

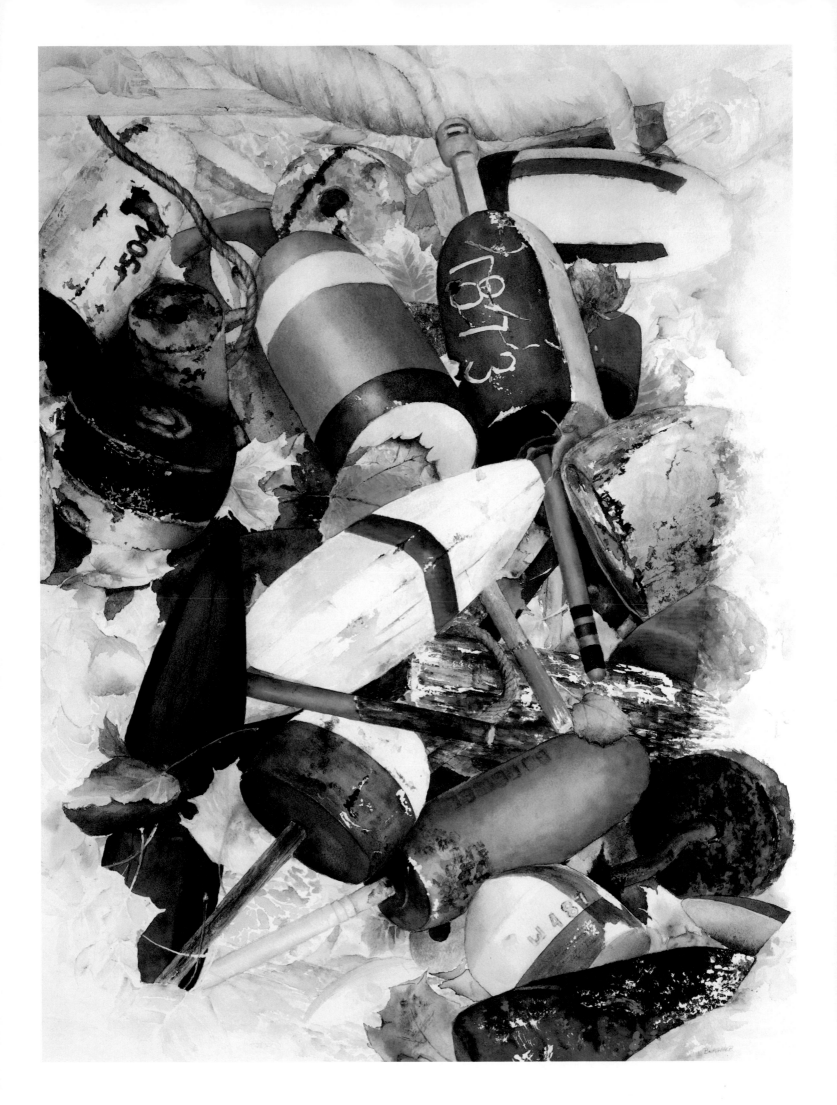

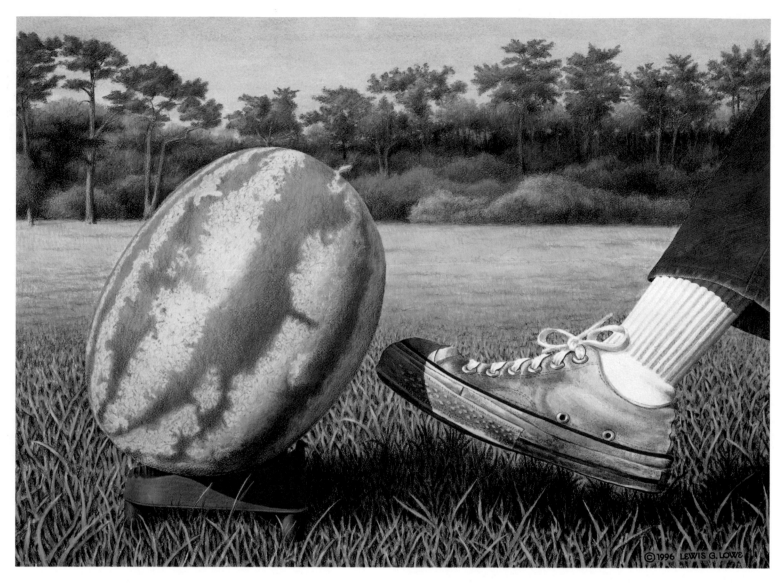

Treat Whimsical Subjects Seriously

LEWIS G. LOWE

The subject matter of this painting is whimsical. The principal color is green to suggest a park where this activity might take place. The scruffy old sneaker adds to the sense of spontaneity. A new athletic shoe would make the painting look too commercial, like an ad for Nike. The impact comes from the careful placement of orange and blue. They represent the beginning (blue) and end (orange) of the action in the painting. Cover these two spots of color and the painting loses its snap. The action continues as the viewer visualizes the splash when the foot hits the watermelon! **TECHNIQUE:** The painting is done mostly in transparent watercolor with glazes for luminosity. Colored pencil is used to strengthen shadows in the grass, to accentuate details such as the fine lines in the watermelon, and to diffuse the trees so they recede into the background.

KICK-OFF!
Lewis G. Lowe, 20¼" × 28" (51.4cm × 71.1cm)

Paint the Feeling of Changing Seasons

JAN BORGNER

While traveling the New England coast, I came upon a stack of buoys behind a fishing shack. Set aside at summer's end, the still vibrant colors of the weathered buoys sprinkled with autumn leaves seemed to capture the melancholy feeling of seasonal change. To represent the inevitable grayness of winter, I softly faded the colors and values toward the painting's edge. **TECHNIQUE:** After rendering a detailed drawing, small areas of white were saved with masking fluid before indicating placement of shadows with light washes. Then I painted one object at a time, almost to completion, with multiple glazes. Detail is done primarily with drybrushing.

WHERE THE BUOYS ARE
Jan Borgner, 28" × 21" (71.1cm × 53.3cm)

SUNRISE, KILAUEA POINT
Laura Mazi, 28½" × 40" (72.4cm × 101.6cm)

Saturated Color for the Drama of Natural Forces

LAURA MAZI

A volcanic promontory with five-hundred-foot cliffs, Kilauea Point on the island of Kauai is today a federal sanctuary for seabirds such as albatross, diving boobies, shearwaters and frigate birds. Allowed to stay overnight at the historic lighthouse, I was up before dawn with camera and telephoto lens to witness a wondrous sunrise of saturated rose and gold light as it skimmed across the inky, crenelated ocean to blaze on an outcropping of glassy black lava rock. In just a moment the phenomenon was gone and, discovered, I was being collectively buzzed by early-morning foraging birds, who drove me off handily by dropping payloads of "Titanium White!" Being thus forewarned about attempting *plein air* painting, I retreated to my Honolulu studio to recollect exalted emotions in tranquility. **TECHNIQUE:** I flooded rosy washes onto the paper over my drawing—no masking was used. I approached the central form in a quasi-pointillist style, outlining sunbeams, droplets and bubbles in the porous rock for texture. Saturated blues from Cobalt Turquoise to Indigo followed. Patterns of spray and foam overlay the massive ocean heaves like a lacy coverlet, disguising wave movements of dark, unfathomable force.

HIKING TRAIL, GARGANTUA, LAKE SUPERIOR
C. Beverly Hagan, 22" × 30" (55.9cm × 76.2cm)

Painting the Spiritual Quality of Light and Atmosphere

C. BEVERLY HAGAN

In Lake Superior Provincial Park in Canada, many of the most beautiful spots are found in remote access locations. Gargantua may only be seen by adventuresome hikers and campers who backpack along the trails. The water is very clear and the beaches rival any in the world. The dewy effect of light shimmering through the woods attracted me very much. Capturing this quality required three main components: many subtle color changes, the use of gray areas to highlight the pure hues, and application of color in patterns. **TECHNIQUE:** The painting began as a loose drawing, followed by an indication of pattern. Some of the patterns were masked. A wet-in-wet technique followed, using a couple of pours in different directions. The painting then evolved slowly as color changes were added to both the wash areas and the masked areas. A stiffer, more durable paper is necessary for this technique.

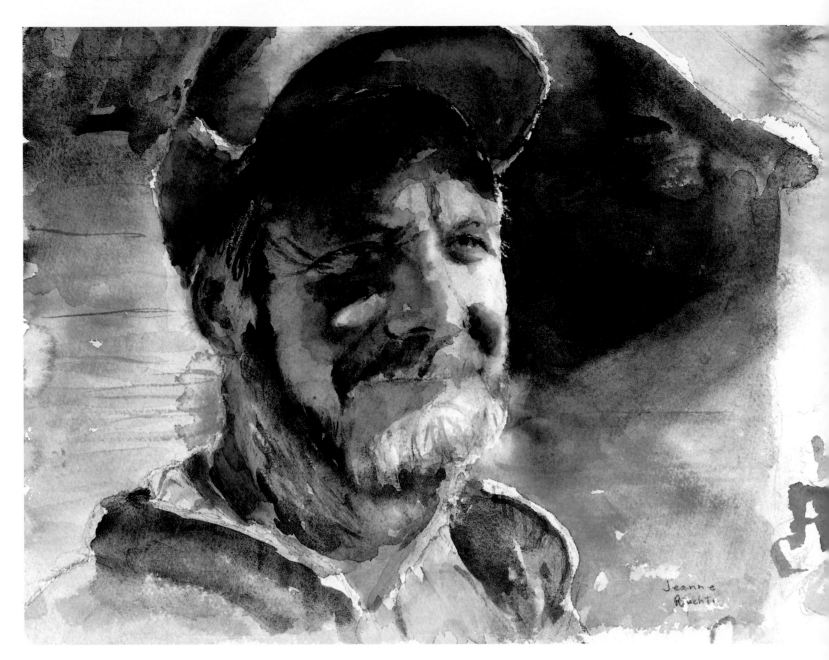

Capture Personality With Reflected Color

EGGS FOR SALE
Jeanne Ruchti, 11" × 15" (27.9cm × 38.1cm)

JEANNE RUCHTI

I use color to portray the essence of a personality. In this case, we had stopped on a sunny day to chat with our neighbor Platt, who was gathering eggs from his chickens. When I saw the brilliant colors of his cap reflecting on his glowing face, I knew I had to paint his friendly smile. I just happened to have my camera, so I snapped some pictures to preserve the light, colors and expression of the moment. Letting bright, pure colors merge together on wet paper is my favorite way to portray emotion. The resulting combinations are endless. When dry, cool colors can be glazed over for exciting color variation in the shadows. The original colors shine through, creating a beautiful underlying foundation that gives life to the subject.

TECHNIQUE: I started the painting by floating yellow and then red onto the wet, carefully drawn face area, letting the colors merge. When dry, I accentuated the glow with dark, cool colors in the background, on the beard, eyes, cap, coat and shadows for contrast. I use 300-lb. rough paper to retain moisture longer, a very large round brush for looseness, and a limited palette of primary colors for overall unity and endless variety.

Save Whites for Impact

CONNIE "ZEKAS" BAILEY

I like to paint in an exuberant and bold manner. Though my son's cat, Sneakers, is black and white, I was excited by the drama of the rich, colorful darks in contrast to the white fur. I mix my darks, drop in colors and let them mix on the paper to retain the luminosity and depth of shadows. **TECHNIQUE:** I work the whole painting, while painting around the saved white. I used very little masking fluid and let the colors mix on the paper during much of the painting, especially for the middle and dark values, to maintain the desired luminosity.

SNE
Conn

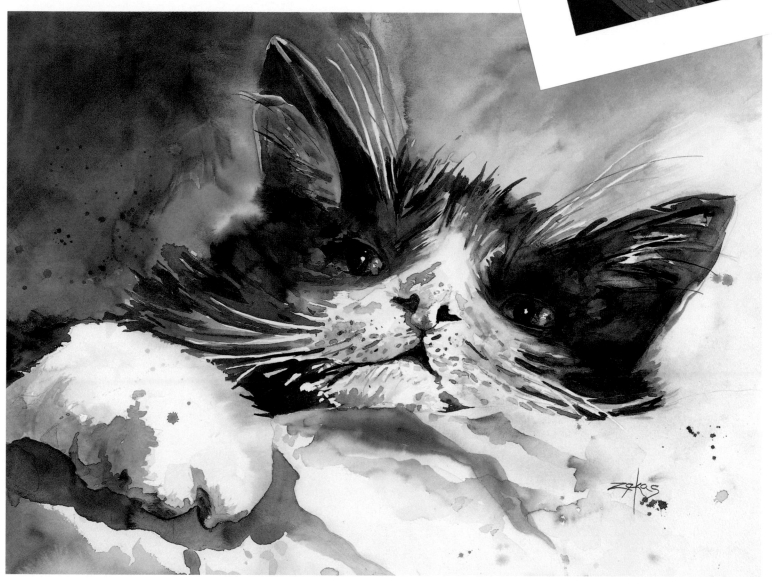

Dramatic Darks Give Lights Luminosity

BETTY CARR

In *Garden Reflections*, I've used the drama of dark values to give the light values their radiance and luminosity. There is a dramatic interplay of light and color using chiaroscuro and maximizing the colors' value range. The flowers' crisp edges are in sharp contrast with the soft, reflective shapes suggested in the dark background. **TECHNIQUE:** When bold spontaneous brushwork and numerous transparent glazes are needed, I'll occasionally use masking techniques such as fluid or tape to protect light values and safeguard detail work.

GARDEN REFLECTIONS
Betty Carr, 24" × 30" (61cm × 76.2cm)

Express Joy With Color

JUDY D. TREMAN

I love color, especially red—what a potent and joyful color! Chinese Red in my silk coat makes a dramatic impact, and is a perfect foil for the simple white dahlias from my garden, echoed by white mums in the silk pattern. While the overall impression of red is compelling, there are actually just a few small areas of undiluted, blatant red. Most of the vibrant red pattern is in shadow. **TECHNIQUE:** After painting the shadows in purples, I added delicate colors in the silk pattern and white dahlias. Last, I apply Scarlet Lake in a single wash, painting around all the small flowers of the pattern. Apply red last, since any time you touch it with a wet brush it will bleed into the adjacent area.

HAPPY COAT
Judy D. Treman, 39" × 28" (99.1cm × 71.1cm)

Warm Greens for the Mood of Florida

HERON ON RAILING
Nancy Darling-Handler, 8" × 12½" (20.3cm × 31.8cm)

NANCY DARLING-HANDLER

This painting relates the thrill I felt while I watched in awe as this reclusive bird flew right up out of the water, perched on the small bridge and then resumed hunting in the stream, oblivious to my presence. To showcase the color in *Heron on Railing*, I used a range of strong, bright color while keeping the values similar and limiting whites. Painting Florida requires a colorful palette and as many greens as the Eskimos have words for snow. **TECHNIQUE:** I enjoy choosing pigments for a painting with their individual properties in mind. I chose Cobalt Violet and Ultramarine Blue for the main body of the heron for their tendency to granulate and create interesting textures on paper. Then I pushed the redness to complement the background greens. I began this painting with an all-over juicy, unifying wash of Cadmium Orange, Alizarin Crimson and Raw Sienna, mixed on the paper, to give the painting the warm, underlying glow of strong Florida sunlight. I used Lanaquarelle paper to allow wiping out leaves and light areas on the heron, and a little masking fluid over the orange wash to create warm highlights in the foliage.

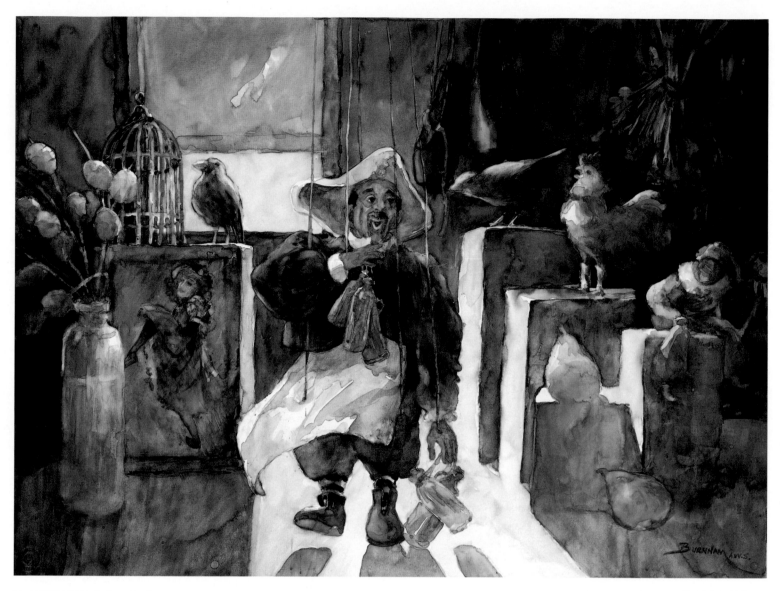

LA MANSARDE (THE ATTIC)
Jane Burnham, 22" × 30" (55.9cm × 76.2cm)

Rich Darks Enhance the Mood of an Artist's Attic

JANE BURNHAM

Jean-Claude is a French marionette I ordered from a friend who was painting in France. Everyone who comes to the studio is delighted with him. I decided to paint him as though he were in an artist's attic, using some of the objects in my studio. The challenge was catching the strong colors while using backlighting for an appropriate mood. **TECHNIQUE:** To add to the fun and challenge, I chose to paint *La Mansarde* on Strathmore's illustration board. The hard finish keeps the paint on the surface for clarity and richness of color. The juiciness of the watercolor pigment in juxtaposition with the smooth, hard surface renders an interesting interplay of light, color and texture.

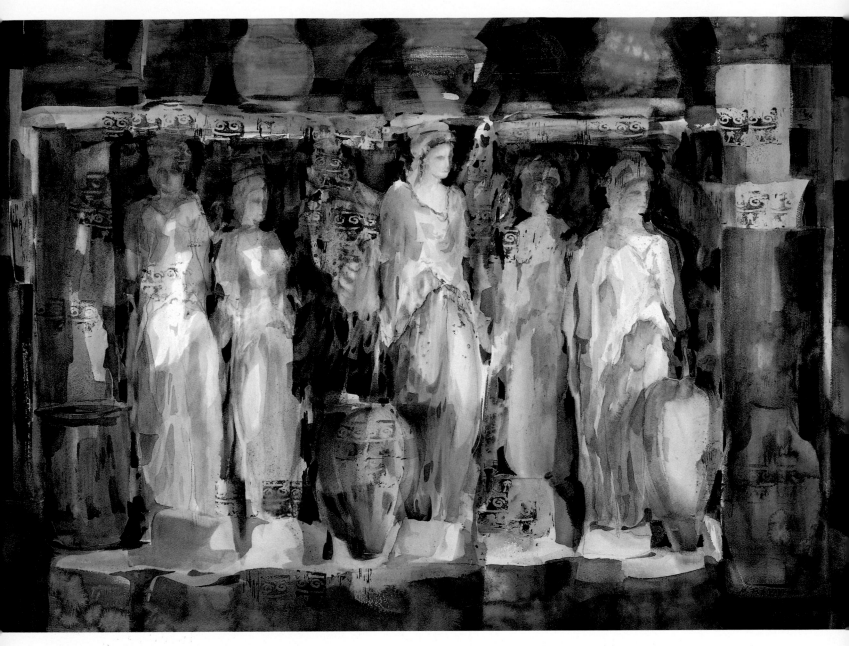

Use Color to Evoke Mystery

MARTHA REA BAKER

CLASSICAL INFLUENCES
Martha Rea Baker, 30" × 22" (76.2cm × 55.9cm)

Inspired by travels to Athens and the Greek Isles, the mystery of a lost ancient culture is evoked in *Classical Influences*. The colors are borrowed directly from the region. The earthtones used in the vessels and the architectural details serve as a backdrop for the transparent blues and greens of the Aegean as they dance across the figures emerging from the shadows. Theatrical lighting and shallow space add to the intrigue and mystery of this contemporary interpretation of a classical subject. **TECHNIQUE:** Working primarily with water media on paper, I build layer upon layer, slowly bringing the subject into focus. Often, I enhance the surface with Prismacolor, pastel pencil, metallic powders or gesso. In *Classical Influences*, I used subtle spattering of gesso and metallic powders into both wet and dry areas. Shapes and designs cut out of mat board are stamped onto the surface, further enhancing the texture and strengthening the motif.

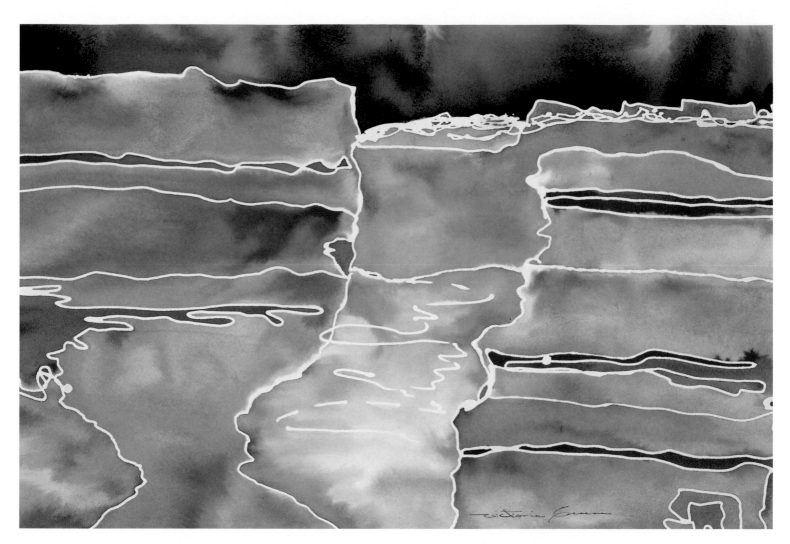

CANYON AT GRAND JUNCTION
Victoria Greene, 14" × 21" (35.6cm × 53.3cm)

Dancing With Color That Laughs

VICTORIA GREENE

Color is never more electric than the first moment sunlight breaks in the aftermath of a storm. Perhaps it is because light has been stripped naked by rain-cleansed air. Perhaps it is the value contrast of receding dark clouds that makes color so explosive. Or perhaps it is what I came to believe the day I was inspired to paint *Canyon at Grand Junction*: color is laughing out loud in a survival celebration! Even within the mist rising from the canyon floor, I saw color giggling as it bounced around in life-giving moisture. To paint with that same joyous energy, I used a brushless, liberating technique learned from Maxine Masterfield. **TECHNIQUE:** I rendered the white-saving line with a hot wax gun, then poured water over the entire surface. The wax formed "dams" creating ponds and mazes. Choosing two warm pigments and a complementary cool, I squeezed generous drops onto the surface. In some areas, I encouraged "flooding" by adding more pigment or water until one color overflowed into another. I removed excess liquid with an eye dropper. Once dry, the wax was scraped off with a credit card.

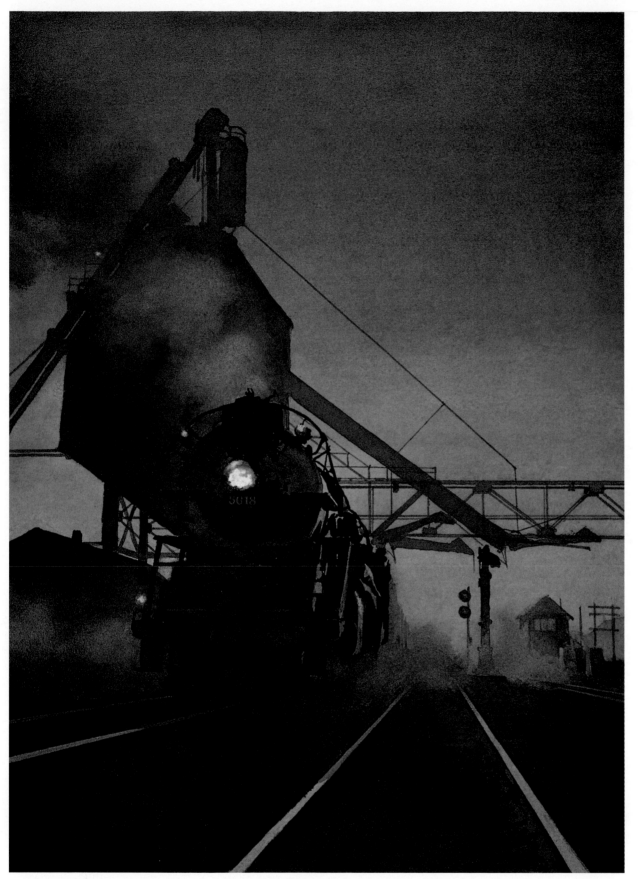

SAILOR TAKE WARNING
Ted Rose, 14" × 10"
(35.6cm × 25.4cm)

Set the Stage with Color Washes

TED ROSE

My paintings are often a series of washes. From light to dark, the first applications of color set the stage. The initial washes are saturated enough to retain color density and permeate darker areas as successive overlays of darker colors build the structure. **TECHNIQUE:** This painting is transparent watercolor without masking or other special techniques, although the locomotive lights were enhanced by lifting.

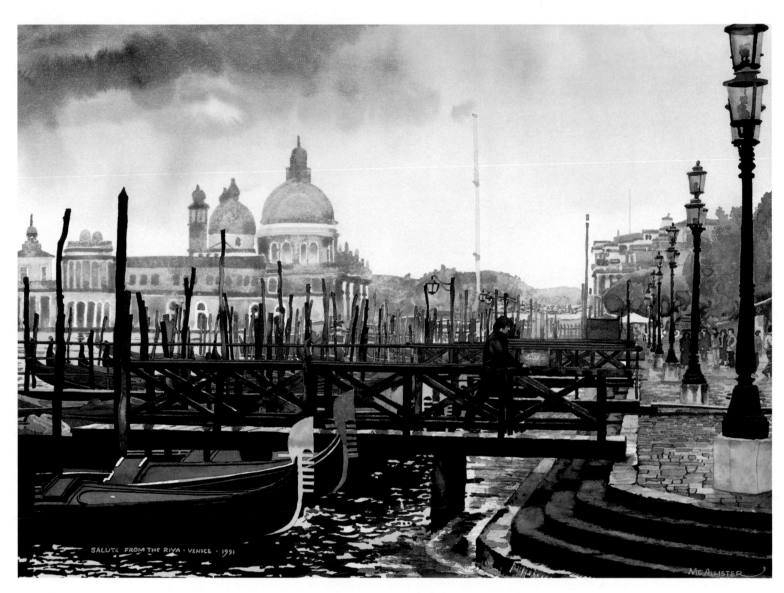

SALUTE FROM THE RIVA
William McAllister, 22" × 30" (55.9cm × 76.2cm)

Capture the Mood of a City

WILLIAM MCALLISTER

As a very young man, I spent some time in Venice, drawing all of the commonly depicted sites. This piece is the result of a trip, to this most irresistibly paintable city, made after a nearly forty-year passage of time. This time I painted in anonymous areas around the marketplace and in narrow streets and canals. Only when I felt comfortable with the people and their unique city did I attempt this first recognizable landmark. My gut feeling was to capture the essence of the city in color, and I focused on what I perceived as the most dominant Venetian atmospheric palette: black, gold and a delicate Cobalt Violet. **TECHNIQUE:** Always go with your gut feelings when painting. I had intellectual doubts about the use of yellow in the water highlights, but after various studies with other combinations, returned to my initial instinct.

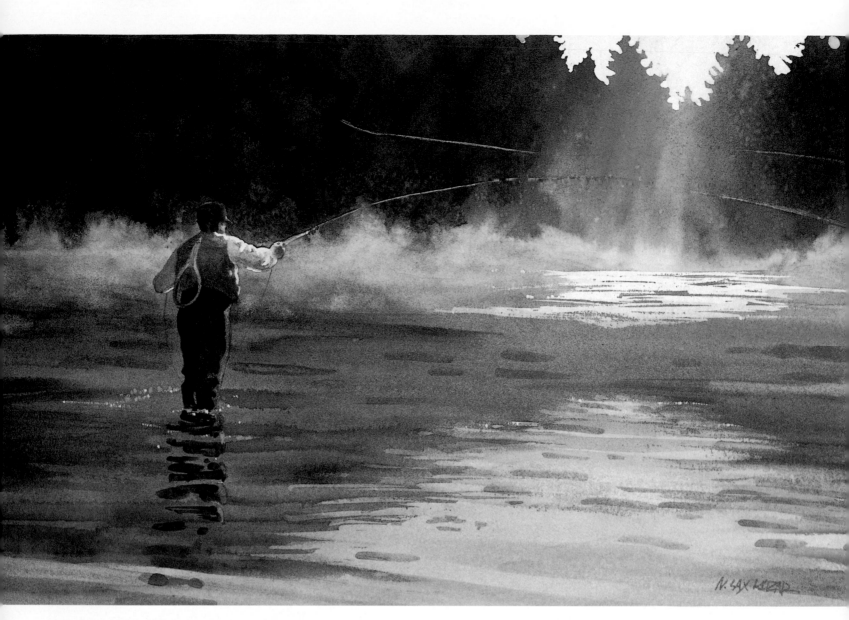

RISING MIST
Nancy Lax Kozar, 8½" × 13" (21.6cm × 33cm)

Use Subtle Color for Early Morning Light

NANCY LAX KOZAR

I am intensely interested in depicting mood in painting. For that reason, I paint early mornings or late evenings when the natural light provides the brilliant contrasts that evoke feeling. In *Rising Mist*, the cool, subtle colors of the forest contrast with the warm rays of early-morning light reflecting on the water and the fisherman. The red hat connects the figure to the warm light source and provides the natural vibrancy of a complementary color. **TECHNIQUE:** I use a limited palette on cold-press watercolor board. The pigment lies on the surface, enabling me to lift color off more easily. I used a damp brush to lift rays of light, and a tissue to create rising mist. Masking solution was used to protect some areas, such as the fisherman's shirt and the light reflections on the water. The fly-fishing line was scraped with the tip of a beveled paint brush.

Sunsets: The Ultimate Visual Drama

BAY SPLENDOR
Donald W. Patterson, 16¼" × 23½" (41.3cm × 59.7cm)

DONALD W. PATTERSON

I love sunsets and sunrises because they create such incredible colors and contrasts. They are the ultimate in nature's visual drama. Painting a sunset or sunrise can be a very humbling experience, but on the other hand, if you bring it off, it can be very satisfying. Blending cold blue into hot orange with wet-on-wet color was a little scary—this was one of those "bite the bullet," "wing and a prayer" paintings—I'm thankful for the result. **TECHNIQUE:** There were two difficult technical problems to resolve in this painting that may not be obvious—the halo around the sun and blending the dark boat hull's waterline into the equally dark reflection. A very limited use of airbrush was the answer. The fine lines of the boat's rigging were accomplished by using a fine-pointed brush and a bridge.

The Color of the Maine Wilderness

CARLTON PLUMMER

Radiant light emanates from behind silhouetted trees to express drama and mystery in this depiction of the Maine wilderness. Complements interact in a variety of ways throughout the composition, adding movement to the mood. **TECHNIQUE:** I began with light washes wet-into-wet on illustration board, leaving white for a waterway and rocks. Subsequent heavier applications were made while the paint was wet, creating soft edges and interaction of color. Designer's white gouache mixed with transparent color was used on occasion to add body and depth. Glazing and accents were applied in the later stages.

WILDERNESS COLOR
Carlton Plummer, 21" × 29" (53.3cm × 73.7cm)

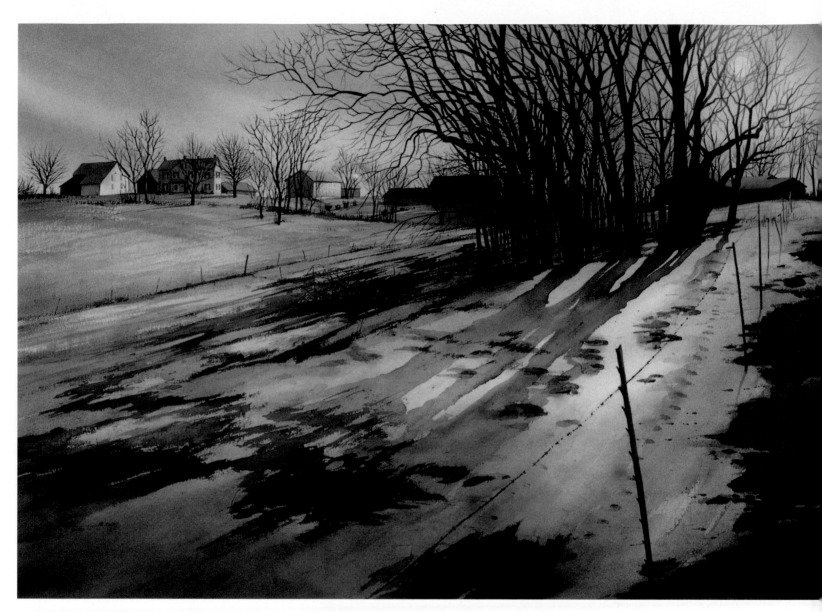

SUNDOWN AT SHERTZER'S
Joann W. Hensel, 28" × 40" (71.1cm × 101.6cm)

Color Overcomes a Bleak Landscape

JOANN W. HENSEL

Sundowns have always interested painters. I noticed this scene as I was ready to head for home one winter day. Actually I was looking at an old stone farmhouse in the opposite direction when I turned toward the sun and was struck by its glare through the trees. The cast shadows on the snow provided the focal point. I completely abandoned the original subject and chose this beautiful view instead. By enhancing the glow of the setting sun on the snow, color overcame a bleak landscape and created excitement. Warm versus cool colors play back and forth throughout the painting. **TECHNIQUE:** A limited palette of Rose Madder Genuine, Alizarin Crimson, Burnt Sienna, French Ultramarine Blue and Cobalt Blue created the basic mixes. When applying the first washes, great care was taken to preserve the white paper where the main shadows create the focal point. The huge mass of trees was painted with a continuous bead of water. I began with cool colors and worked into warm colors as they "bleached out" nearer the sun.

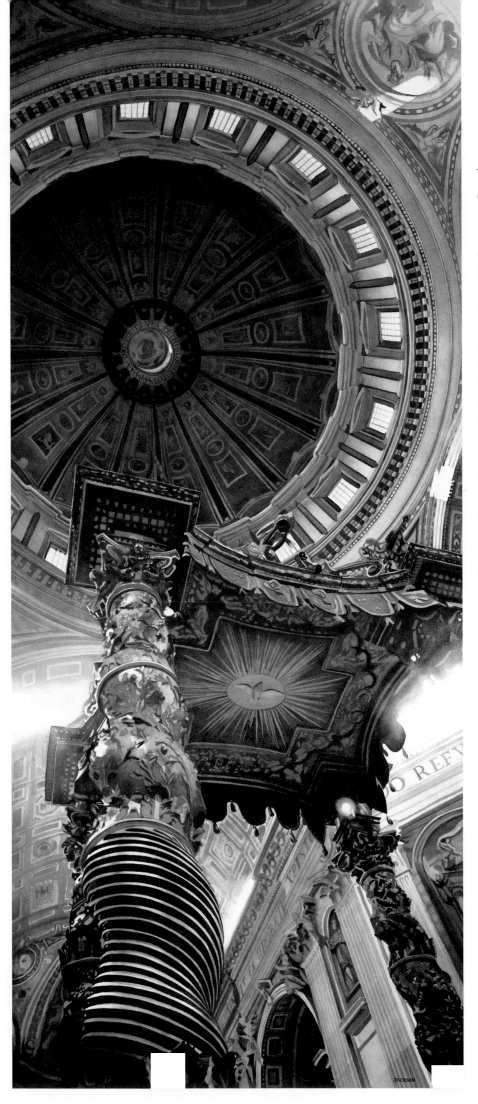

Powerful Expression With a Limited Palette

PAUL JACKSON

A wide range of colors was not necessary for my interpretation of the dome of St. Peter's Cathedral. Generally I paint with intense colors, but to balance this very energetic composition I used only four semineutral colors I had left over from a box set. The low-intensity color helped to create the mood while suggesting a great depth through atmospheric layers. Ambiguous light sources with soft-focus edges bathe the grand architecture in a golden light and create a mystical energy that makes a dynamic statement about the power of this place. **TECHNIQUE:** Raw Sienna, Raw Umber and Burnt Sienna create the intense warmth that radiates from *A Glimpse at the Gate.* The keen observer will also detect spots of Prussian Blue in the underpainting. However, I chose to limit the use of this complement in favor of a more analogous color scheme.

A GLIMPSE AT THE GATE
Paul Jackson, 56" X 23" (142.2cm X 58.4cm)

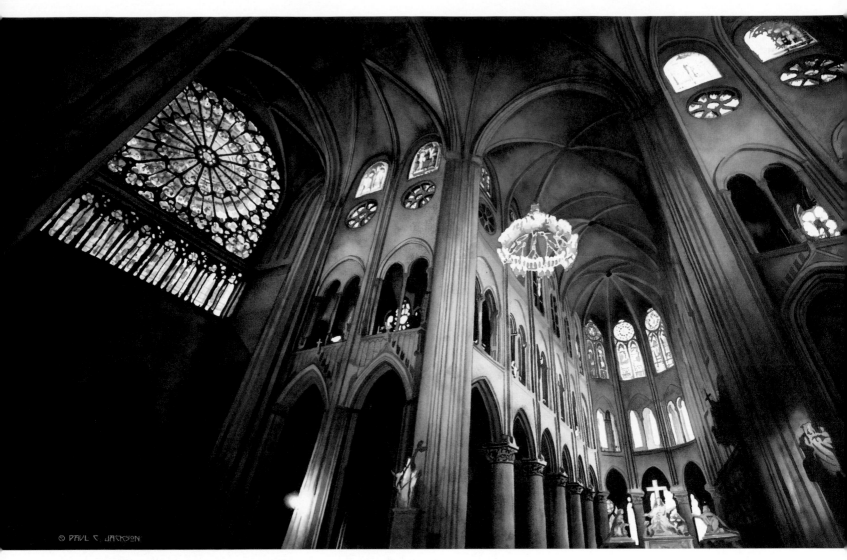

Soft Illumination and Dramatic Deep Shadows

GOTHIC TWIST
Paul Jackson, 26" X 40"
(66cm X 101.6cm)

PAUL JACKSON

Soft illumination and deep shadows set the stage for *Gothic Twist*. Blues and violets are not all that lurk in the shadows that haunt this interior depiction of Notre Dame Cathedral. The pure colors that punctuate the focal points were layered to create the darker, semineutral colors that deepen the shadows and dominate the rest of the painting. The neutral colors help to temper the energy of wildly exaggerated perspective lines, and at the same time express an atmosphere of antiquity. The temperature of my color scheme is driven by opposing light sources: the cooler, natural light from the windows and the warmer, artificial light from the chandelier. In order to draw the viewer into the composition, I allowed the warmer light to dominate, inviting closer inspection of the interior.

TECHNIQUE: A lot of the initial detail that I paint gets "destroyed" in the painting process. To convey a sense of atmosphere I will glaze over large areas with clear water, softening the hard edges. After several glazes, the original details are almost unrecognizable. This helps to unify large areas of detail and push objects into the background.

Communicate Meaning With

SYMBOLISM *or* COLOR SCHEMES

Color has always had symbolic emotional significance. Red is hot, either angry or excited. Blue is cooler, perhaps peaceful or a bit melancholy. Artists make use of this phenomenon to suggest a meaning or even to portray a specific message. Some of the color schemes in this section don't have definite meanings, but they serve to give form and direction to the artist and the viewer.

Conrail Caboose is a silent tribute to an endangered American phenomenon: the caboose. Because the demise of the caboose is imminent, I presented the image in front of an evening sky. With the sun having set behind it, the railcar falls into deep shadow. In my industrial paintings, I pair a wildflower with an engineered component—since sunflowers frequently populate rail corridors, I used one in the composition. A vibrant play of complements is set up between the sky, plant and caboose.

—MARY LOU FERBERT

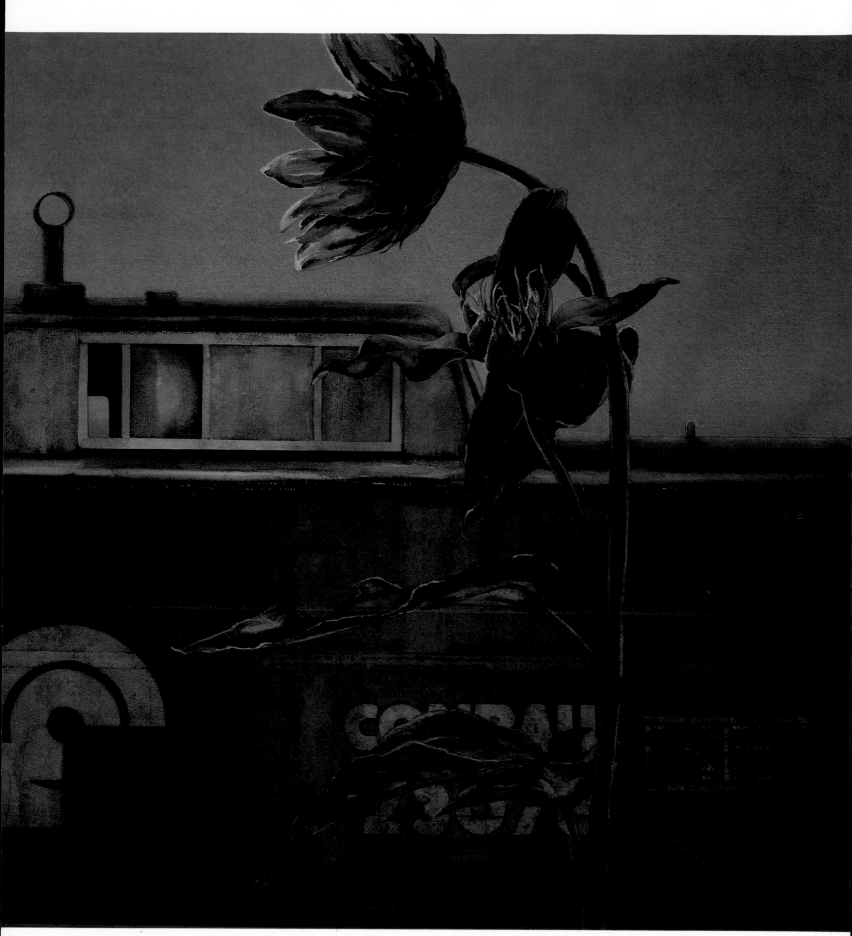

CONRAIL CABOOSE
Mary Lou Ferbert, 38¾" × 58¾" (98.4cm × 149.2cm)

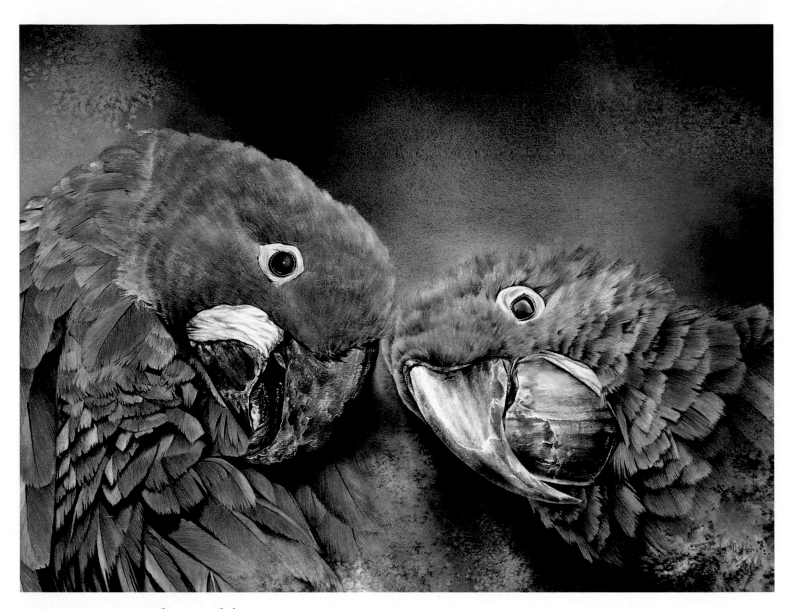

Manganese Blue Adds a Dreamlike Texture

BRENDA MILLS

My choice of subject matter in *Fading Blues* was influenced by my experiences with large macaws, as well as a recent study of the characteristics of various pigments. Experimenting with my new palette, I chose colors from the cool range of blues and greens specifically for their temperature and unique properties. These colors—Manganese Blue, Antwerp Blue and Aureolin Yellow—depict the cool, tropical colors. Manganese Blue separates as it dries, adding an abstract, dreamlike texture. **TECHNIQUE:** Masking fluid protected portions of the birds' faces while the backgrounds were painted wet-into-wet. I poured colors together, tilted and splattered clear water into the background. Foreground subjects were painted using a drybrush technique. Layers of blue were painted into the feathers with a fan brush. Cotton swabs blended and lifted color, giving the feather tips an iridescent glow.

FADING BLUES
Brenda Mills, 18" × 24" (45.7cm × 61cm)

Add Discords to an Analogous Color Scheme

ELIZABETH GROVES

I attempt to take a step beyond the ordinary by developing many different layers of interest for the observer. It's fun to let the viewer discover the hidden elements that add a touch of humor and tell a story: Will the birds notice the lurking cat in time to fly away? **TECHNIQUE:** Add spice to an analogous color scheme by using slightly discordant colors in close proximity. For example, putting Manganese next to Cobalt creates an eye-appealing vibrancy. To get the most punch from the colors I use them intensely, fully saturating the paper.

NOCTURNE
Elizabeth Groves, 38" × 30" (96.5cm × 76.2cm)

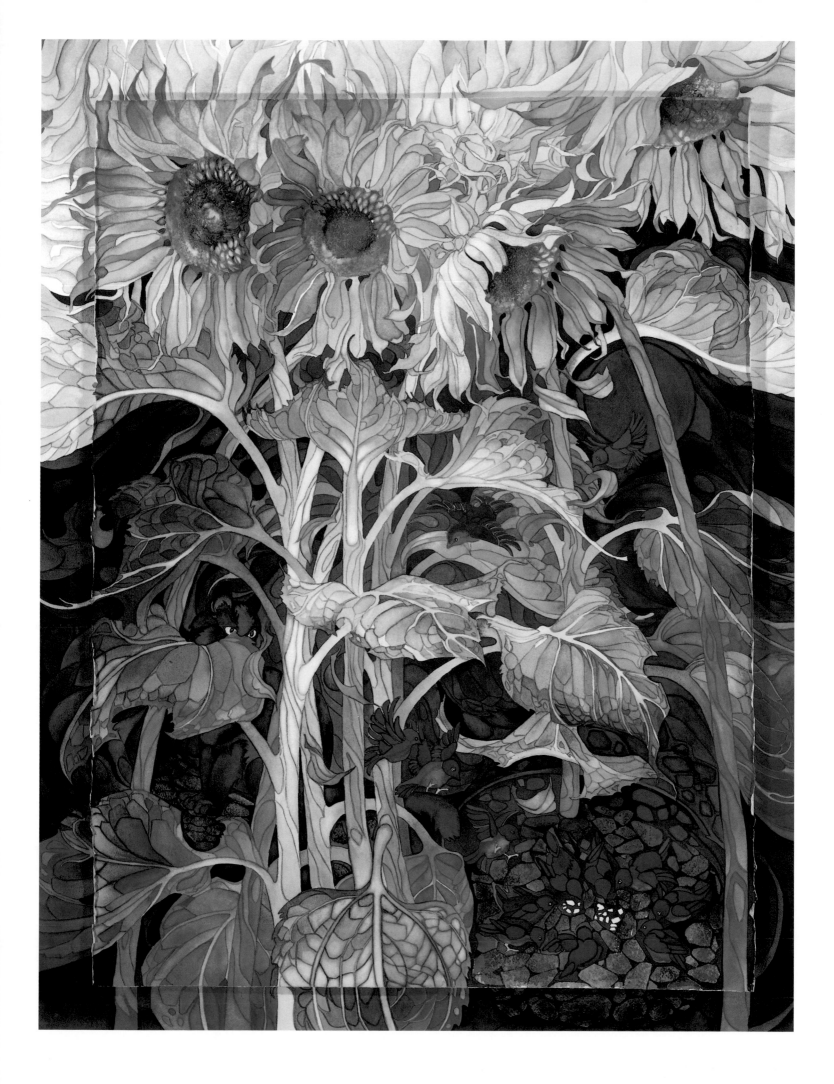

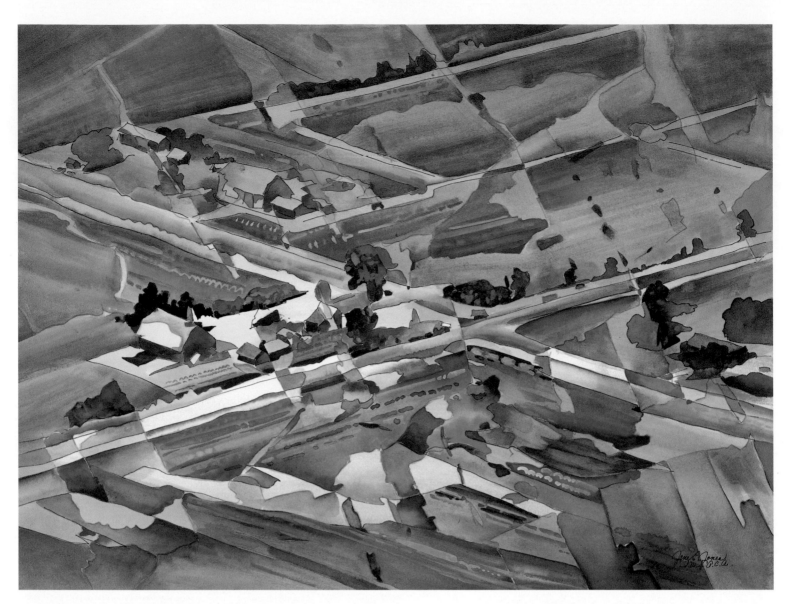

GREEN PASTURES
Jane E. Jones, 22" × 30" (55.9cm × 76.2cm)

Unify and Brighten Your Colors With an Analogous Color Scheme

JANE E. JONES

An abstract shape was superimposed onto the realistic drawing of an aerial view and incorporated into the realistic forms, creating a strong oblique structure. In the beginning, the abstract forms were painted red, the complement of the dominant color green, to create a contrast. I unified the painting by using colors closely related to each other on the color wheel, going from red through blue-green by way of yellow, which enabled the colors to look brighter than they actually are.
TECHNIQUE: The dimension of space is enlivened by working wet-into-wet on 140-lb. Lanaquarelle cold-pressed paper, using a transparent palette of colors, and using a gradual movement of intensity from brighter to duller, moving from foreground to background.

Lively Color Symbolizes Celebration

DOTTY HAWTHORNE

The glowing yellow and rich green of fresh lemons and limes piled high in a market display caught my eye. I purchased several and accepted the challenge of capturing their vivid, contiguous colors. A white plate provided a reflective "stage." While working, I considered the bitter, yet appealing character of these citrus fruits and thought of my daughter leaving home, even as we congratulated her upon her graduation. I realized that celebrations often involve a "bitter" aspect as well as joy. **TECHNIQUE:** After lightly rubbing paraffin on cold-pressed paper to preserve highlights and achieve texture, I glazed the limes with layers of Sap Green and the lemons with mixtures of warm and cool yellows. To achieve a mood of celebration, I used bright complementary staining colors, accented with acrylic metallic gold paint, set off with an India ink outline.

BITTERSWEET
Dotty Hawthorne, 14" × 21½" (35.6cm × 54.6cm)

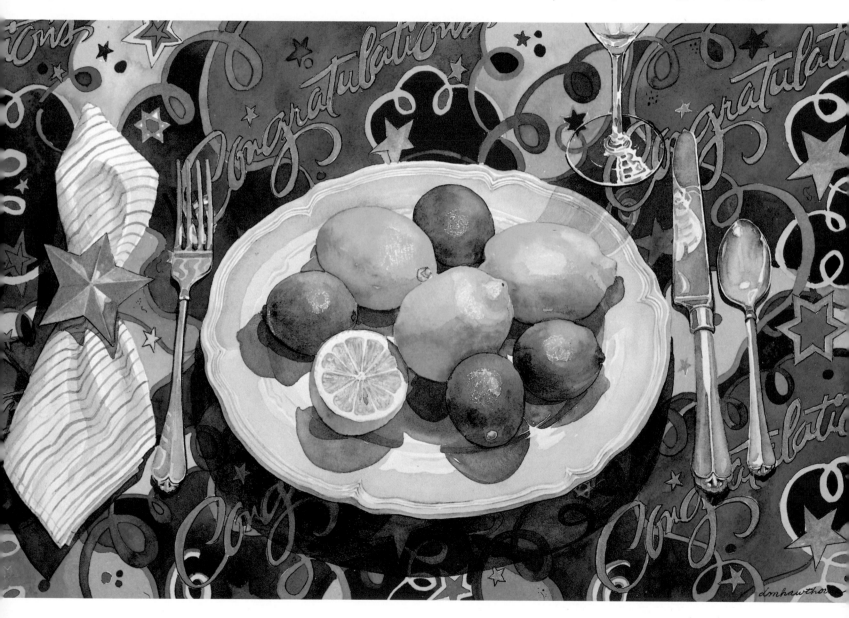

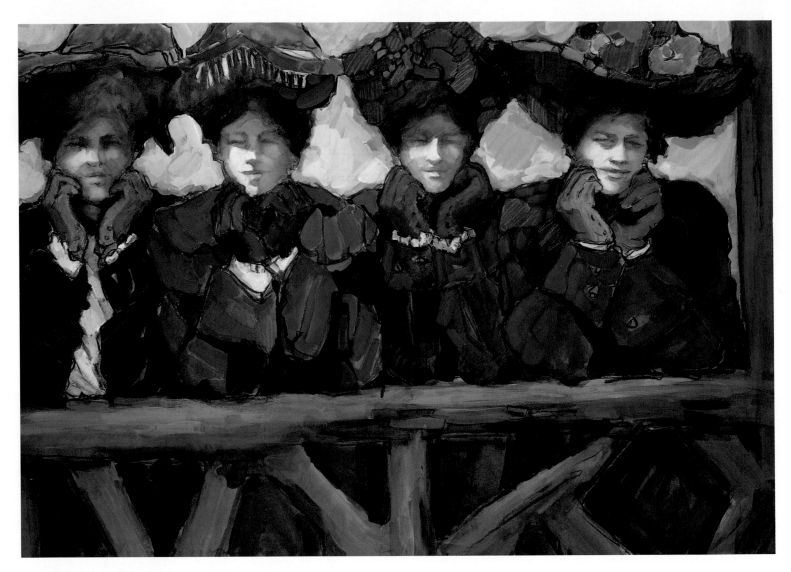

Communicate Spirituality With Harmony

CONNIE DILLMAN

To me a painting is a means of communication, a way to tell the viewer what I feel, my spirituality. This doesn't just happen, but is a result of the relationships between pattern, composition, texture and color. I use mosaic-like patterns to weave the colors throughout the piece, every color relating to every other color. Grays are as important as more vivid colors. **TECHNIQUE:** The essence of the Victorian era is more than old-fashioned dresses and headgear. In *Victorian Ladies*, the deep, jewel-like blues, greens and maroons are used to tie the feelings together and to create the desired mood. Watercolor crayons are used to tone down the colors.

VICTORIAN LADIES
Connie Dillman, 30" × 40" (76.2cm × 101.6cm)

Reveal the Meaning of a Japanese Character

MARK E. MEHAFFEY

Kanji is an ancient form of Japanese picture writing. I try to handle the Kanji character as a form or shape in space, giving it depth and meaning beyond the intrinsic meaning of the shape. In terms of color choices, I had two major considerations. First, I wanted to keep the ground subdued—light enough in value to show some depth when shadows were applied, but subdued with complementary layers of color so that the Kanji character would pop forward in space. Second, I wanted the round shape that denotes the blossom part of the character to really stand out and say "flower." I did this by increasing value contrast and adding intense, saturated color in this area. **TECHNIQUE:** I practice Kanji so my depiction is spontaneous and swift. I then paint the character in masking fluid and allow this to dry. The painting is then worked from back to front. When I really want color to "pop" I use a very intense, lightfast ink.

KANJI: FLOWER
Mark E. Mehaffey, 43" × 28" (109.2cm × 71.1cm)

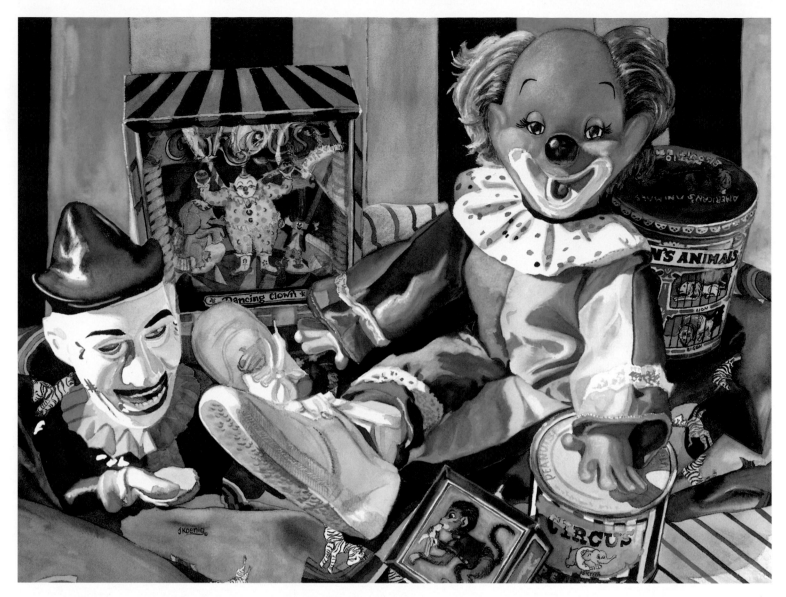

A High Key Color Range Adds Vibrancy

JUDY KOENIG

HA, HA, HO, HO, HE, HE
Judy Koenig, 22" X 30" (55.9cm X 76.2cm)

Painting in a photo-realistic style makes it necessary first to plan very carefully the color of the objects, then to pay extreme attention to detail, scale and shapes. The shoes on the clown doll were actually one shoe found in a park. When I tried it on the doll it was so comical I had to paint it. The color of the clown's clothing gave me the idea for the color scheme. Three sets of opposites were used. The analogous colors of yellow, orange and red were played against lavender, blue and green. Because yellow and orange have a short value range, the painting is high key, with about ten percent dark—this adds to its vibrancy. **TECHNIQUE:** I use photography and projection as time-saving tools, but keep my collectibles in front of me for accuracy in color and dimension. I mask to save my whites, but scrub the edges to soften them when the masking is removed. My favorite color is Winsor & Newton Cobalt Blue, because of the many tasks it does so well, its beauty and its clean mixing and layering capabilities.

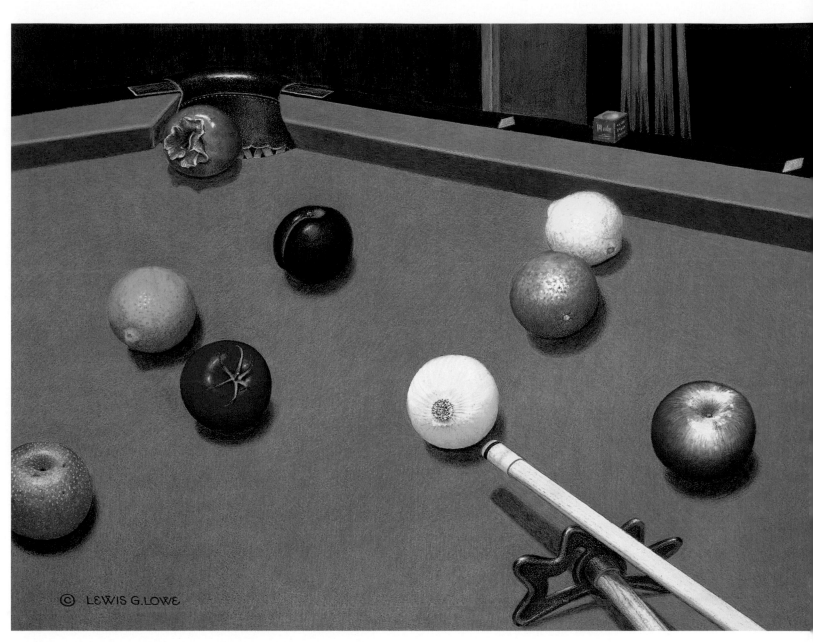

Share Your Humor With the Viewer

PERSIMMON IN CORNER POCKET
Lewis G. Lowe, 20" × 28" (50.8cm × 71.1cm)

LEWIS G. LOWE

The bright colors of billiard balls contrasted against the solid color of a pool table has always intrigued me. On second glance at this painting, the viewer realizes that this brilliant rainbow of color is not a set of ordinary billiard balls, but fresh fruit. The discovery enables the viewer to share in the artist's conception and personal brand of humor. One problem, though, with using real fruit was that the persimmon didn't come in season until a full month after the other fruit were painted—it was a long wait! **TECHNIQUE:** A rough color rendering of each fruit was cut out and moved around on a pencil layout until the composition was satisfactory. Masking fluid reserved white for each fruit until painted. The cue stick directs the eye in a strong diagonal from cue ball (onion) to eight ball (plum) to persimmon. The felt was painted with a mixture of Winsor Green and Winsor Blue. Colored pencil was used to highlight the fruit and table rim.

An Analogous Color Scheme Suggests Repose

JEAN KALIN

I am fascinated by the human form in all its complexities. In *Summertime*, I wanted to convey the fleeting lazy days before adulthood. An analogous color scheme of blue-purple, purple and red-purple, with a green complement, was used to suggest repose. Small orange and blue-green discord accents add spice.

TECHNIQUE: The velvet pillows and the denim jumper were done on dampened areas with a ½-inch flat nylon brush after the background was worked wet-in-wet to keep soft edges. Carefully saving the white areas, many glazes of color were added. Shadows were floated over dry color and drybrush details were added.

SUMMERTIME
Jean Kalin, 17½" × 28" (44.5cm × 71.1cm)

A Monochromatic Scheme Conveys Softness

BILL JAMES

Because of the soft, delicate nature of the subject matter, I wanted to keep the painting monochromatic. The tutu the little girl wore was blue, so I decided to use a slightly darker shade of the same color for the background. Also, by keeping the space around her simple, all the attention would be on her face and the eloquent pose she was in at that moment. Her face stands out because of the cooler shade of blue. **TECHNIQUE:** I paint on a smooth, gesso-coated surface of either illustration board or watercolor paper. I can then rub out lighter areas and add darker passages in a painterly fashion.

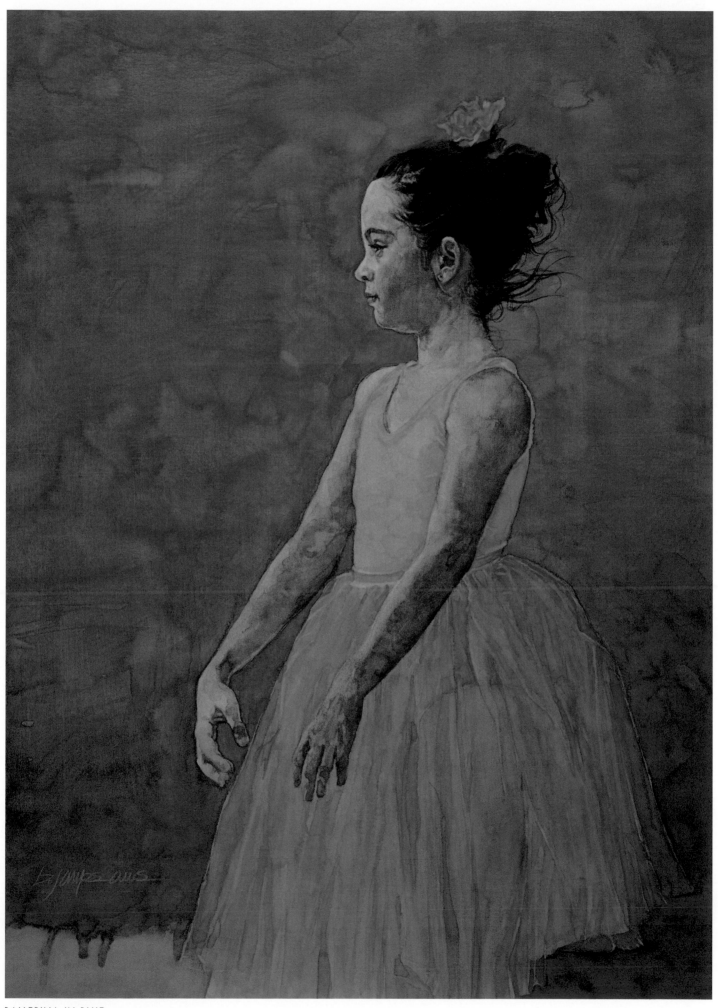

BALLERINA IN BLUE
Bill James, 30" × 21" (76.2cm × 53.3cm)

Portray Atmosphere With a One-Color Theme

MARC A. CASTELLI

In the autumn, watermen of the Eastern shore shift their focus from crabbing to the harvesting of oysters. The watermen start work early in the morning in order to get their catches back to shore before the heat of early afternoon causes spoilage to set in. *Dog Days* portrays the quiet of a late afternoon on an Eastern shore dock, when most of the day's work is done. **TECHNIQUE:** I built this painting's color theme around the color yellow to represent the heat of the afternoon. I wanted to show an atmosphere thick enough with heat that the air becomes a veil. I first washed most of the paper with a medium value of New Gamboge. Its staining pigment allows for clean glazing. I chose the complementary purple/violet mix for shade. The resultant gray or dark is translucent enough to allow the base yellow to shine through, keeping to the theme of heat. I reinforced the yellow in places with a rich mix of Cadmium Yellow Pale and more New Gamboge, then painted the darkest values with a warm purple instead of a flat gray.

DOG DAYS—TILGHMAN ISLAND
Marc A. Castelli, 18" × 24"
(45.7cm × 61cm)

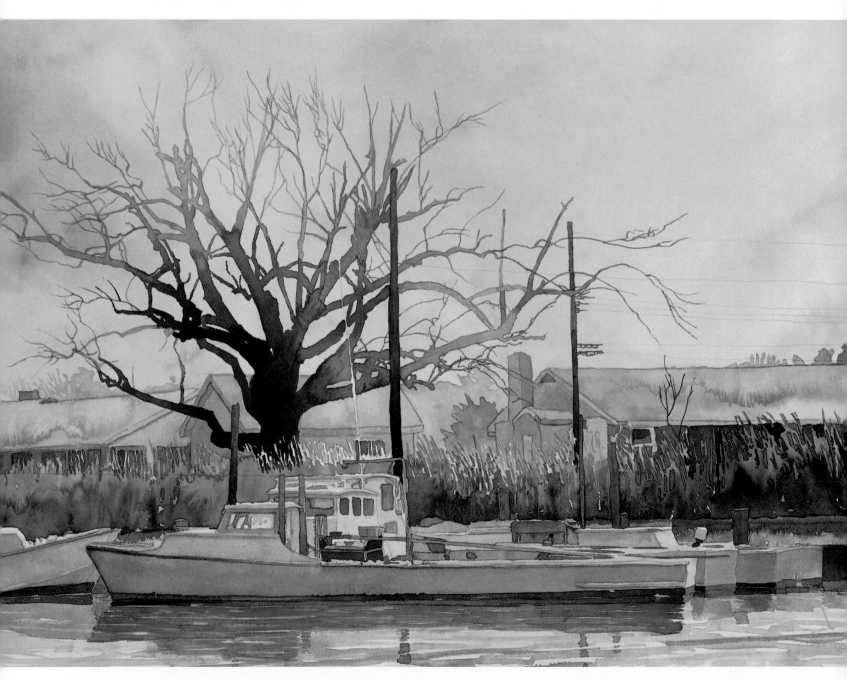

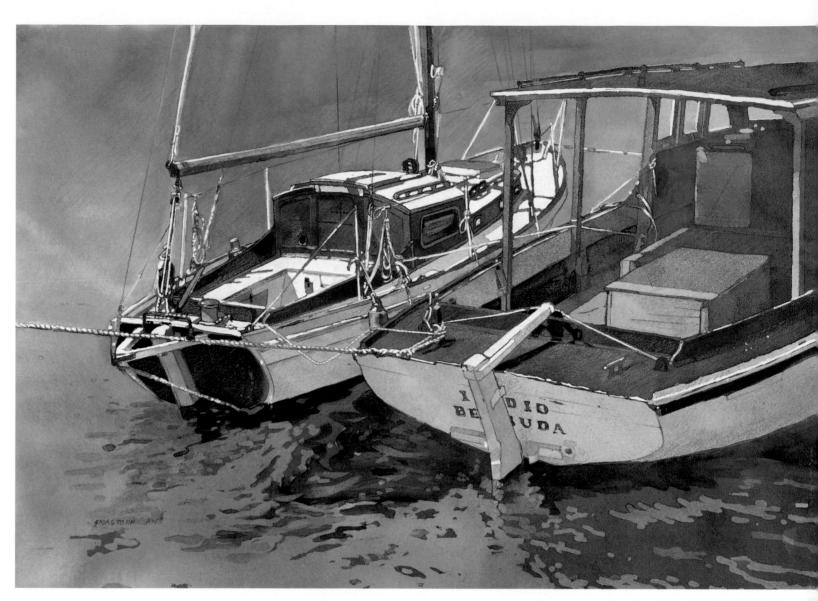

BERMUDA BLUES
Jean H. Grastorf, 20" × 25" (50.8cm × 63.5cm)

Paint the Color of a Place

JEAN H. GRASTORF

Bermuda to me is the color blue: clean, clear, fresh, deep blue. The decks and hulls of the boats catch the bounce of light from sky and water. Because no color exists without the influence of other colors, the full spectrum is here, held together by the dominance of blue. **TECHNIQUE:** By masking the areas of the boats that I wanted to keep white, I was able to pour my colors without restriction. Three transparent and staining primaries were poured simultaneously. Some mask was then removed, and more mask added to preserve areas of the first pour. Subsequent pours brought the painting almost to completion. Direct painting and watercolor pencils were used to sharpen needed detail.

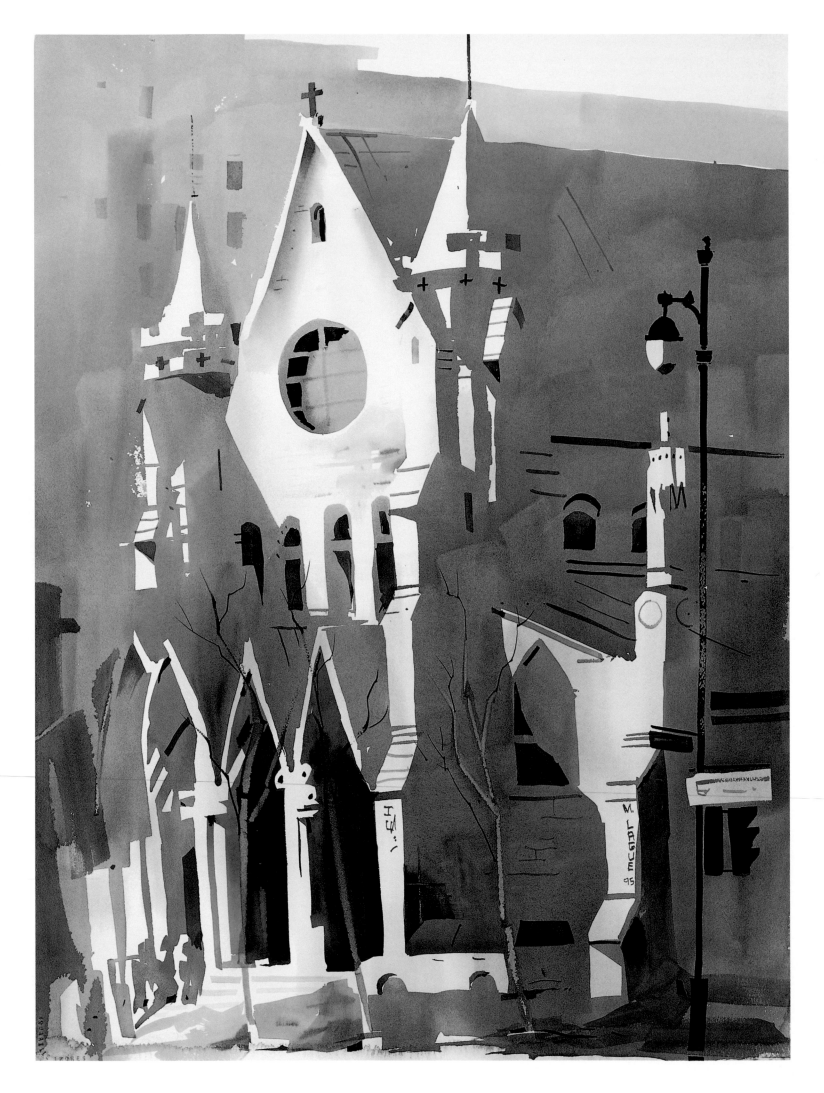

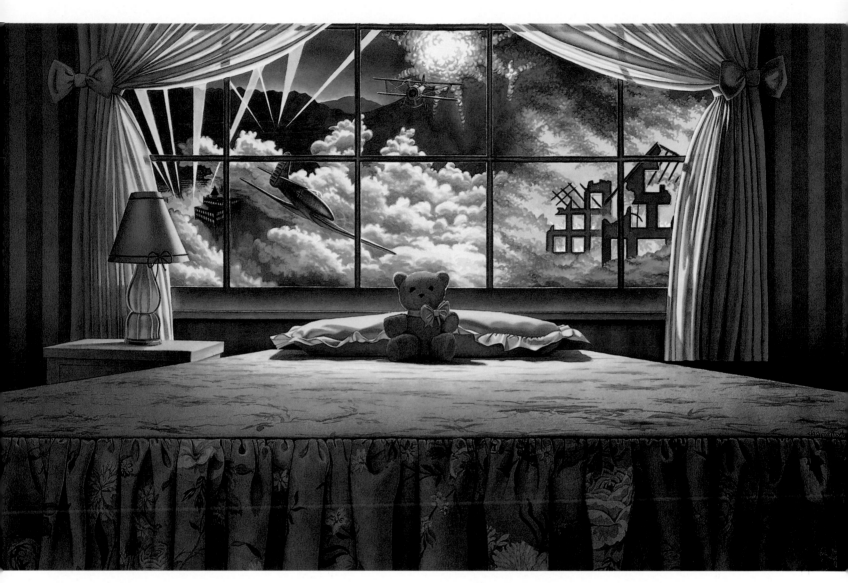

Blue Dominance for a Cool Fall Day

MARK LAGUË

As a general rule, I don't plan which colors I am going to use in advance. In *Cathedral*, however, I had very strong ideas about color at the early design stage. As I sat drawing this warm gray structure on a cool fall day, the idea of an overall blue dominance seemed obvious. **TECHNIQUE:** I knew when I began this painting that I wanted to minimize the granular quality of my washes. For this reason, Winsor Blue was used in almost every wash. Its smoothness, viscosity and staining quality made it ideal paint for this situation.

CATHEDRAL
Mark Laguë, 30" × 22" (76.2cm x 55.9cm)

Colors Symbolize Opposing Forces

SHARON MACZKO

The act of war outside a child's window symbolizes various opposing forces—the domineering against the passive, the absurd versus the commonplace, the vulgar mind against the noble heart. To effectively illustrate these extremes I incorporated radically opposing colors—oranges (the negatives) against the blues (the positives). The passive blues of the room don't penetrate the exterior; however, the violent yellows and oranges significantly intrude upon the interior. **TECHNIQUE:** For this self-created still life I enhanced the colors with various colored light bulbs. Blue bulbs produced a subdued tone for the bedroom walls, while yellow bulbs created the vibrant, ominous glow on the bed.

BACKYARD
Sharon Maczko, 25¾" × 40" (65.4cm × 101.6cm)

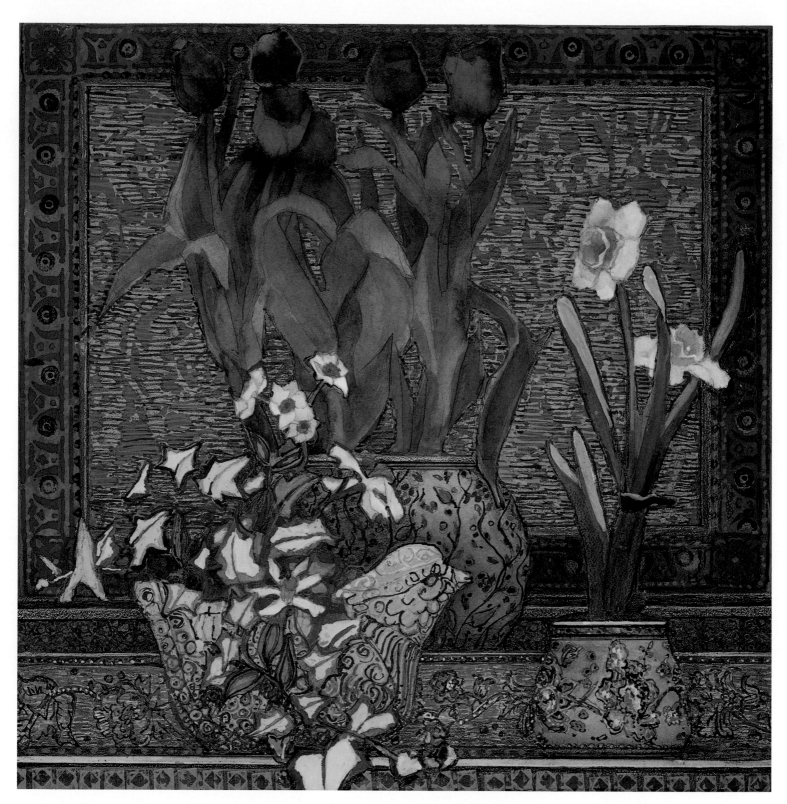

A Contrasting Color Can Enliven a Color Scheme

ANNE BAGBY

SPRING PATTERN
Anne Bagby
32" X 24" (81.3cm X 61cm)

The color scheme in this painting was inspired by a rack of fabric in a store. Every bolt was bright blue and yellow. Translating these colors into a painting required colors not quite as bright as the fabric that inspired them. I use color schemes in all my work, adjusting the colors I see rather than copying them exactly. **TECHNIQUE:** With the blue and yellow scheme, I felt the painting needed the red to enliven it. I usually use a very bright red, made by layering Alizarin Crimson over Cadmium Yellow, but felt like this very powerful color would overpower the delicate yellows, so I kept the reds dull and in the background where I wanted them. Paint reds and blacks early in the painting process since they have a strong impact. I used a ruling pen to do any line work in this painting as well as stencils and rubber stamps.

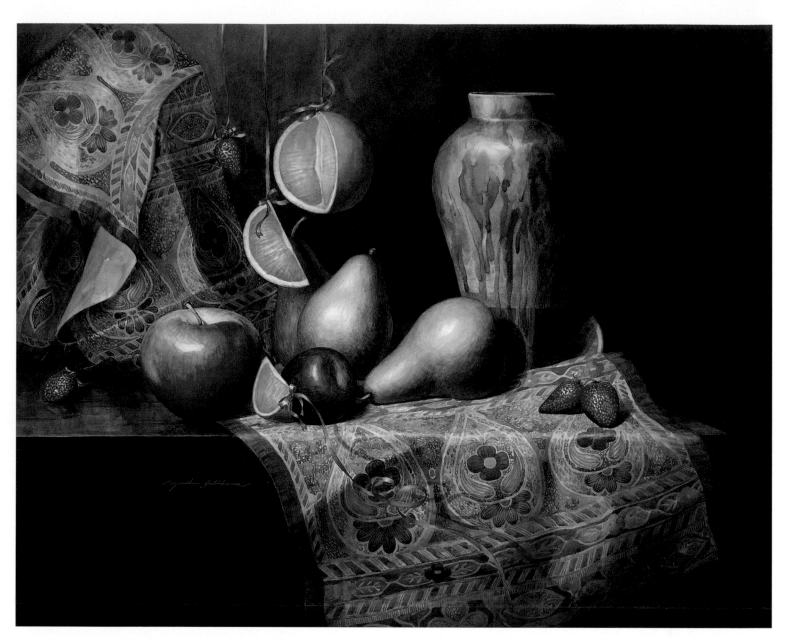

Create a Warm Indoor Glow

YUMIKO ICHIKAWA

STILL LIFE #6
Yumiko Ichikawa, 22" × 28" (55.9cm × 71.1cm)

To emphasize the brilliant colors of the fruits in a warm light, I chose a dark brown color for the background. I also painted the vase and the cloth in brown to harmonize the entire warm color scheme. The small touches of blue in the ribbon and the blue patterns of the vase and cloth emphasize the warmth of the other colors as well as adding contrast. For the fruits, I used the most intense colors, very rich, yet not gaudy. The strong contrast between the light and the shadow areas also creates the brightness of the fruits. **TECHNIQUE:** At the final stages of painting, I used a very small brush to glaze colors. Arches hot-press paper seems to work well in layering delicate and detailed colors.

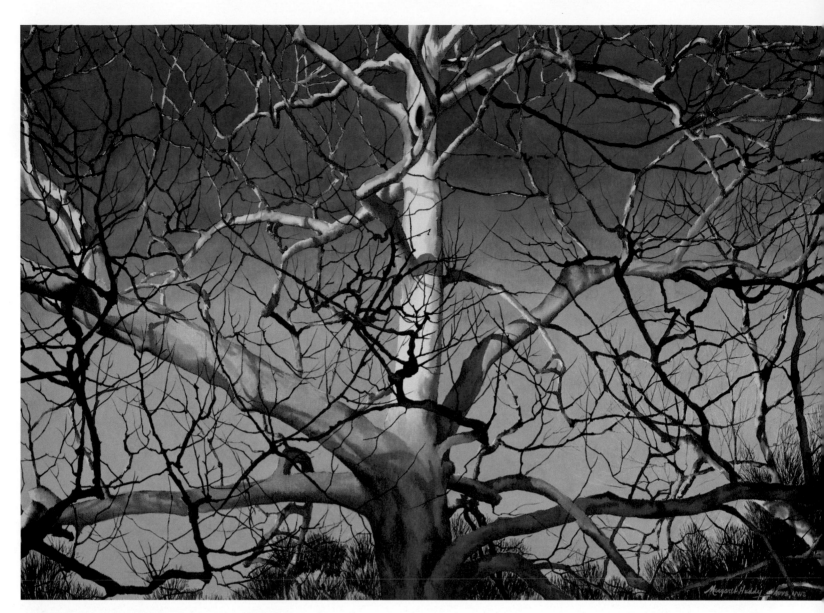

Try Gamboge for the Warm Light at Dusk

MARGARET HUDDY

To capture the warm light at the end of the day on an aged sycamore tree, I glazed the trunk and limbs with Da Vinci's Gamboge. After the glaze was dry, I worked on each segment, putting in the shadow colors wet on dry paper, fuzzing out the edges with clear water. I drop a warm color like Alizarin Crimson or Magenta into the blue shadows against the cool sky to create a rounded feeling of bounce light from the setting sun. **TECHNIQUE:** I use a limited palette of primary colors that includes four reds, three yellows and four blues. By eliminating earth colors and creating my own secondary colors, I am able to achieve very glowing colors.

SYCAMORE, DAY'S END
Margaret Huddy, 29½" × 41"(74.9cm × 104.1cm)

Use a Surprise Color

DIANNE NANCE

Color games are fascinating. Here I played a series of clear, transparent reds and violets against a dull orange carpet and background. With these red-based colors in place I made the apple an unexpected yellow-green. **TECHNIQUE:** My favorite color device is to shift color temperatures across an object. The tray shifts from warm to cool—Scarlet Lake to Winsor Red to Alizarin Crimson to Acra Violet—all in the same value. For extra color impact, the color of the adjacent object may shift in the opposite direction, cool to warm.

VISHNU
Dianne Nance, 30" × 22" (76.2cm × 55.9cm)

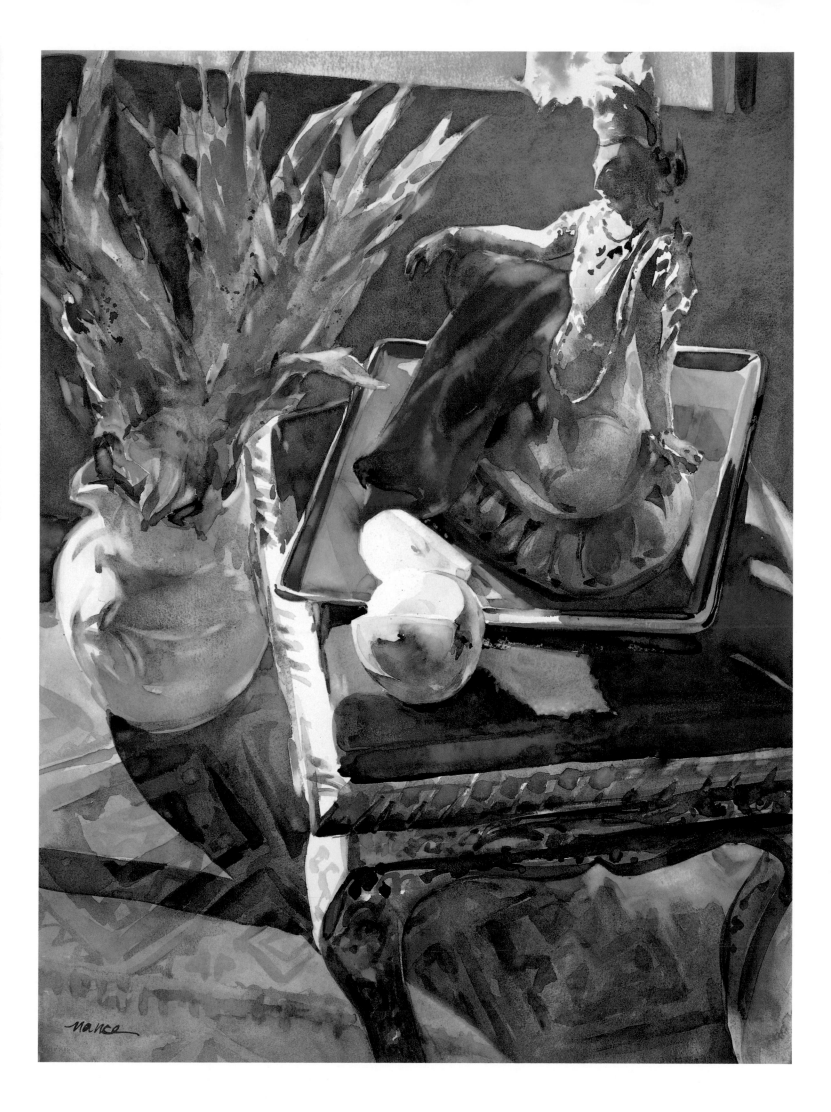

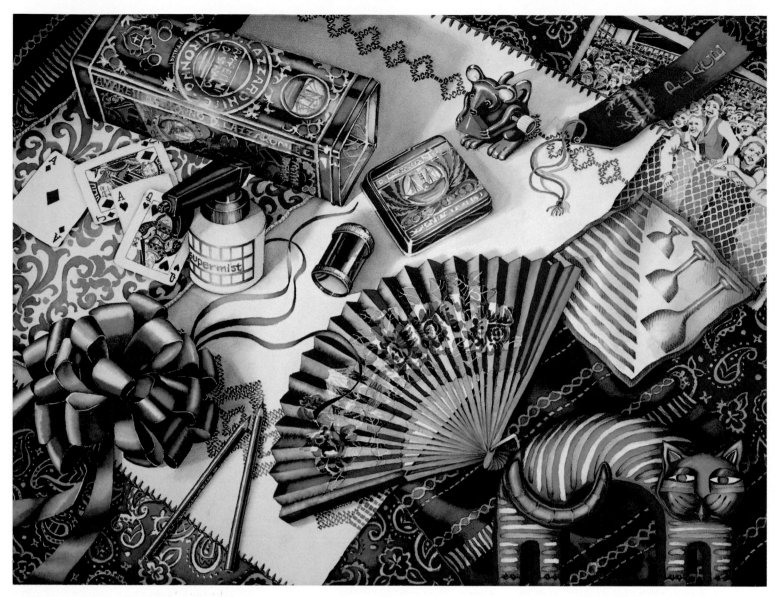

Painting Symbols of the "Red" Emotions

RED GAMES: PUSHING MY LUCK
Joyce Grace, 22" × 30" (55.9cm × 76.2cm)

JOYCE GRACE

Red evokes feelings and images of love, luck and passion. Red is bold and risky—all the things I'm not! The idea for this painting began with the quirky cat figurine and the old windup mouse toy. As I collected other objects and fabrics for this still life, I thought about the games people play that involve the "red" emotions. Flirtation, partying, gambling, competition and pursuit—the cat and mouse—all seemed to fit. Finally, the colored pencils and sharpener represent one of the most risky and important passions in my life: making art. **TECHNIQUE:** When using the color red, I have been concerned about lightfastness, so I have been very pleased with the wide range of quinacridone- and perylene-based reds now available. They are permanent, transparent and retain more of their brilliance when dry. I do a lot of glazing using pthalo blues and greens to neutralize my reds and mix violets. The quinacridone and perylene reds have strong tinting strength and aren't overwhelmed by other pigments.

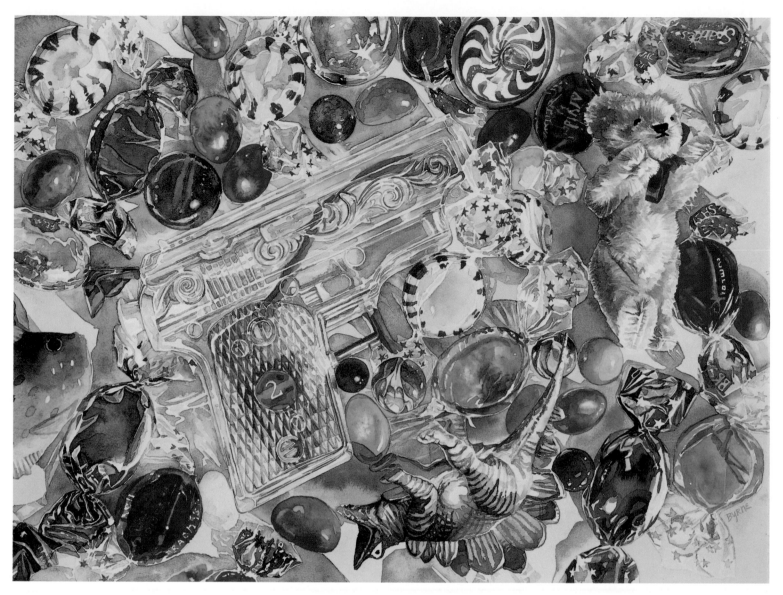

YOUNG BOYS' TOYS
Mary Gregg Byrne, 16¼" × 21½" (41.3cm × 54.6cm)

Symbols of Childhood and Parenting

MARY GREGG BYRNE

The inspiration for this painting came from my young son's appalling interest in guns. Despite my best efforts, they became part of his play—squirt guns were one of our compromises. The tiny teddy is a relic of my childhood. The bear's posture of hostage or surrender reflects my feelings about parenting a child with a mind of his own. The spiraling composition also comments on my lack of control. I used bright colors, mixing them on the paper as much as possible, to portray the enthusiasm and energy of childhood. **TECHNIQUE:** For this painting, I used masking fluid to preserve whites so I could work loosely, wet-in-wet, around them. I painted freely, trying to produce interesting abstract shapes and create realism when viewed from a distance.

Make a Connection With One Color

JEAN UHL SPICER

Working from fresh flowers, I select colors and shapes, arranging them in attractive settings that often don't resemble the still-life setup. For this painting I chose a theme of analogous colors, starting with yellows, oranges, fuchsias and lavenders. The next challenge was to develop negative shapes to describe form by using an important connecting color: purple. The unified purple shape tied the elements together and projected the white vase. **TECHNIQUE:** Rather than masking out white shapes with the resulting hard edges, I worked around the whites, observing which edges to keep or soften immediately. Colors essential to this piece were Permanent Rose, Permanent Magenta and Cadmium Scarlet.

AUTUMN BLEND
Jean Uhl Spicer, 14¼" × 21½" (36.2cm × 54.6cm)

Listen to the Flowers

DONNA BROWN

I love flowers! When I cut and gather them, the flowers themselves determine the feeling of the painting—be it delicate or vibrant, formal or playful—each has its own message. For me this painting is about the richness of life. It is as if the flowers have gathered energy all summer and now are at their "saturation" point. I chose to use the Cobalt Blue vase to enhance the play of color between warm and cool, light and shadow. **TECHNIQUE:** I tried some of Daniel Smith's quinacridone paints here and found them to be rich and luminous. Although I often work from fresh flowers, I painted this using a photograph for reference. A photo is great for capturing dramatic shadows and allows more time to work out a composition without worrying about flowers wilting.

SATURATION
Donna Brown, 21¼" × 29¼" (54cm × 74.3cm)

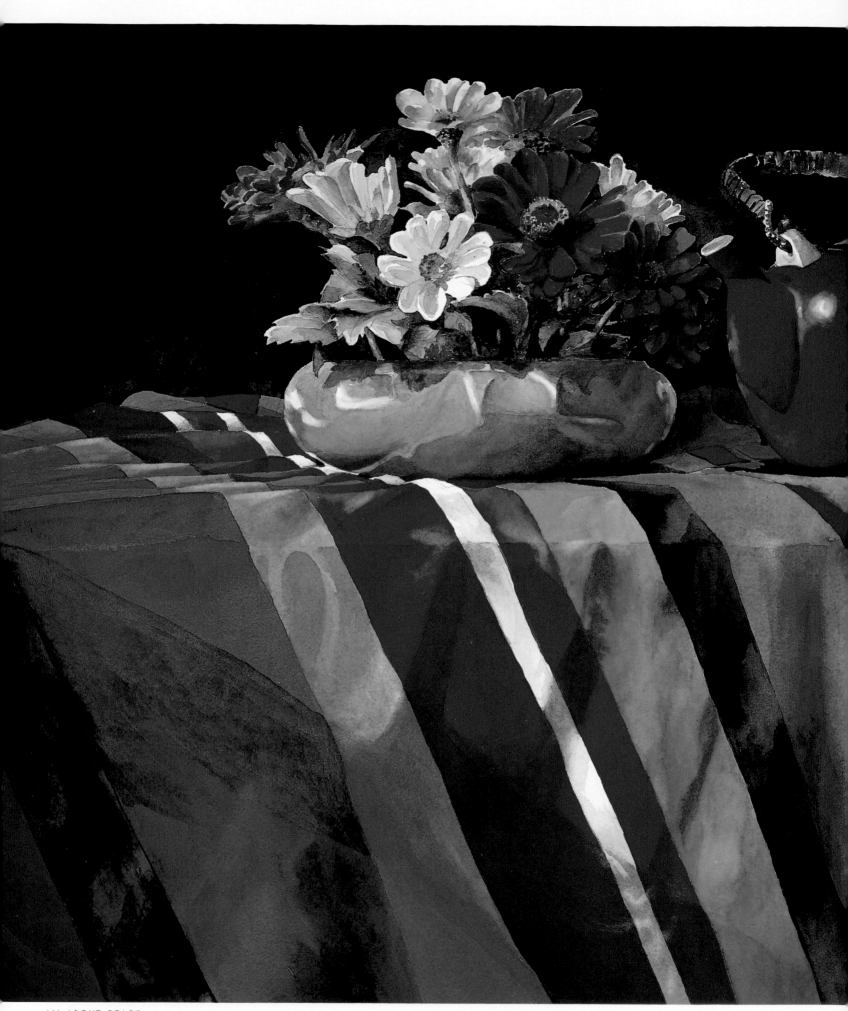

ALL ABOUT COLOR
Pat Billeci, 21" × 28" (53.3cm × 71.1cm)

Break Color Habits by
EXPLORATION
and BOLDNESS

Using bold, pure, highly saturated color is one way to make your paintings stand out in a crowd. These colors must be used with caution, but that's no reason to neglect them. When you feel you are stuck in a color rut, try making bold changes, any changes. On the following pages you will read how some artists get bold with color and some explore other new paths.

When I reach a plateau in my painting, I explore new directions. For several years my palette had consisted of earth pigments with only one or two strong color notes. I challenged myself to break free of old ideas and restrictions. My goal was to use many colors and every type of pigment. I stocked up with a variety of new paints and set up a still life with some of the boldest and brightest items from my kitchen. I added some colorful flowers from my garden and got to work. This piece was the result.

—PAT BILLECI

Brilliant Primaries for an Italian Summer

SORRENTO, ITALY
Ong Kim Seng, 15" × 22" (38.1cm × 55.9cm)

ONG KIM SENG

Being from Singapore, most of my paintings depict scenes in Nepal, Tibet and countries in southeast Asia. The colors are usually earthen and the approach rather subtle. When I painted Sorrento, Italy, it was a great change and a new experience for me. The Italian summer is a rich combination of vibrant colors. I colored the cliff on the right with a warm Brown Madder to contrast the turquoise blue sea, using primary colors to achieve strong color contrast. **TECHNIQUE:** *Sorrento, Italy* is painted on cold-pressed paper using transparent watercolors. I leave the bright areas white because no white is whiter than the paper.

Combine Bold Colors and Sharp Angles

HARRIET CURTIN ERMENTROUT

Patterns and angles fascinate me. Here, I was also attracted to the contrast of greens against the Burnt Sienna and red tones; a new color, Rose Madder Genuine, was added to my palette for this work. Edgar Whitney was one of my early teachers. Ed challenged me to be fearless with color, a goal I still set for myself. **TECHNIQUE:** I used overlapping washes of color to create shadows. To obtain subtlety, I drag small scraps of mat board over areas for a graining effect, seen in the brick and doorway. The scraping is done just as the paint begins to dry. Try starting with heavy colors; later you can lift out areas or blot a section that needs to be lighter.

URBAN RENEWAL
Harriet Curtin Ermentrout
15¼" × 20¾" (38.7cm × 52.7cm)

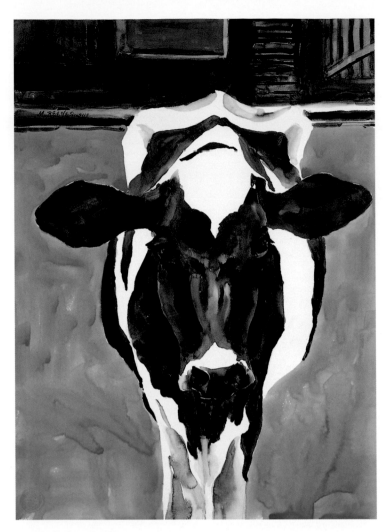
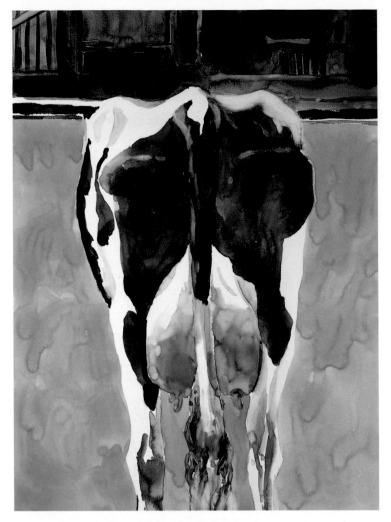

Unexpected Color Increases Impact

MARYANNE REEVES

The inspiration to do a series of cow paintings came after a visit to a dairy farm while on a painting trip to Louisiana. From my photos, I selected ones that were most interesting to me; they were all direct front or back views. For fun, I decided to combine both views in one painting and *Front Side—Udder Side* evolved. After completing the painting, I felt the need for something to give it some "zing" and painted the white background bright yellow. It seemed to work and was so enjoyable that a later series of paintings depicting other animals and even people had unexpected color in the background—yellow, hot pink and bright blue.

TECHNIQUE: Using the plate surface illustration board provides many options. I love the way the paint sits on top of the paper, giving the ability to lift out areas.

FRONT SIDE—UDDER SIDE
Maryanne Reeves, 20" × 30" (50.8cm × 76.2cm)

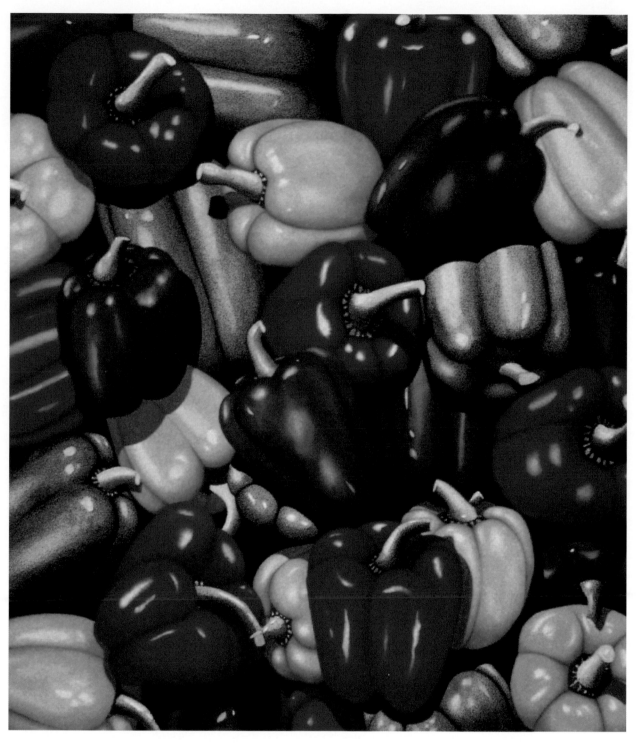

Bold Point of View and Bold Color

JERRY W. BOWMAN

TUMBLED PEPPERS
Jerry W. Bowman
44" × 38" (111.8cm × 96.5cm)

Tumbled Peppers uses familiar subject matter in a close-up, directly overhead point of view. Coupled with oblique lighting, strong underpainting and a brilliant palette, this point of view elicits drama and immediacy from a still life. Also, an overhead point of view helps eliminate perspective problems. **TECHNIQUE:** Peppers are intensely colored, translucent and reflective. This makes them fun, but challenging. To meet this challenge, I strongly underpaint with one or more blues (Cerulean and Winsor), purples (Bayeux Violet and Permanent Mauve), red browns (Venetian Red and Brown Madder) or red orange (Vermilion). I then overpaint with Cadmium Red Deep, Cadmium Yellow Medium, Cadmium Orange, Vermilion or Bayeux Violet, depending on the final effect desired.

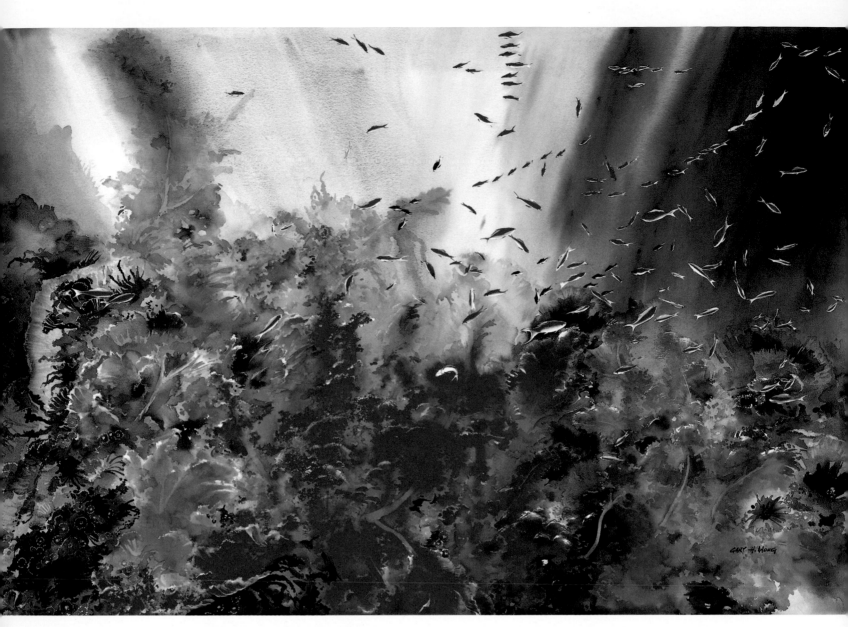

Let Your Colors Enjoy the Water

GARY H. WONG

CORAL WORLD
Gary H. Wong, 29" × 41" (73.7cm × 104.1cm)

I like to wet the paper and mix colors on it, letting them run over the paper and into each other like a stampede of horses. When the paper is fairly dry, I round up the colors by applying stronger pigments, and white or black color. Somehow, the painting develops as a complete piece. I love the mystery of the sea and its creatures. *Coral World* was inspired by photographs taken while visiting major American aquariums. I chose this paper size because a smaller format would not be capable of expressing the magnitude of underwater seascapes. **TECHNIQUE:** I began by cutting fish patterns from masking tape and placing them on the paper. Next I wet the paper, applied paints, and let them mix with each other. After the paper dried, I lifted the fish patterns off and added the details of the corals and the fish.

ORIGINS: REVELATION
Mary Ann Beckwith, 22" x 30" (55.9cm x 76.2cm)

Craving Color on Long Winter Days

MARY ANN BECKWITH

White, cold, snow-covered, long-lasting winters typify conditions on the ice-covered shores of Lake Superior, where I live. The winters give me an overwhelming urge to paint large fields of intense color. I gather pure primary colors and begin to paint large passages of bright, pure, saturated color. My hunger for cheerful color is richly satisfied. **TECHNIQUE:** Pure, liquified watercolor pigment and inks are prepared in spray bottles for application, and a webbing fiber is stretched over a hot-pressed paper surface. Intense colors are sprayed over the surface, layered next to and over one another. Then the board is tilted in different directions so the color will flow. When the initial pattern is established, refinement is made with washes of watercolor and careful application of watercolor pencil.

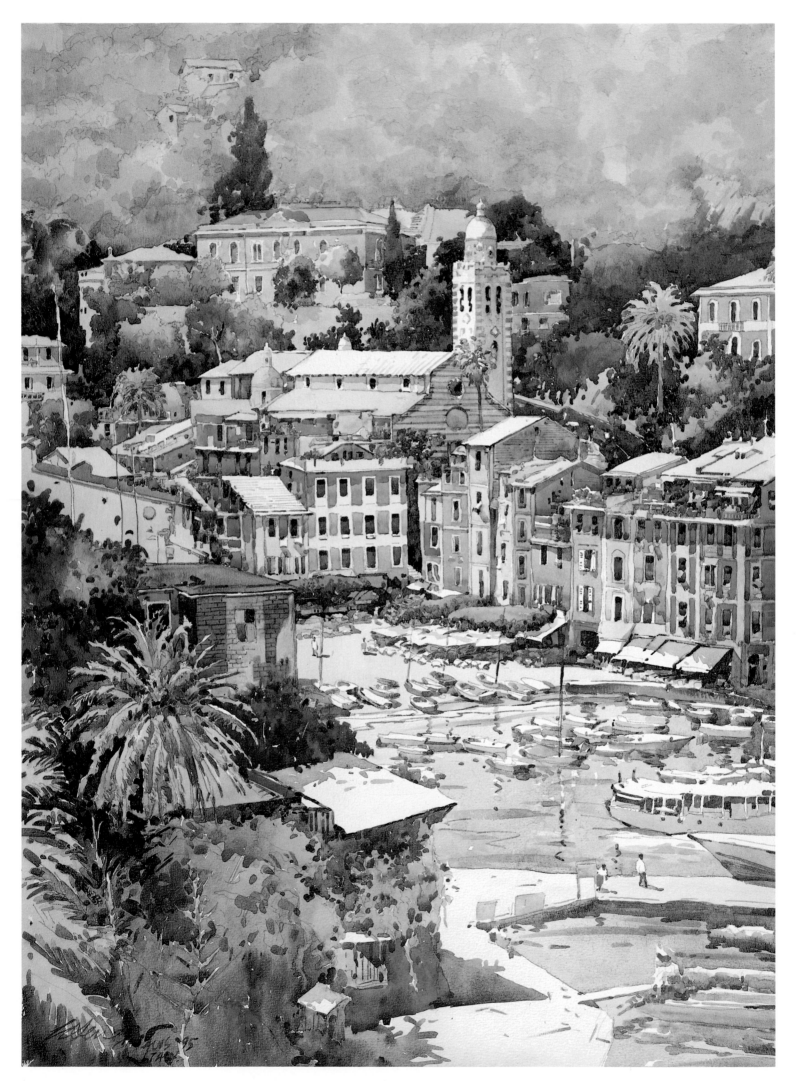

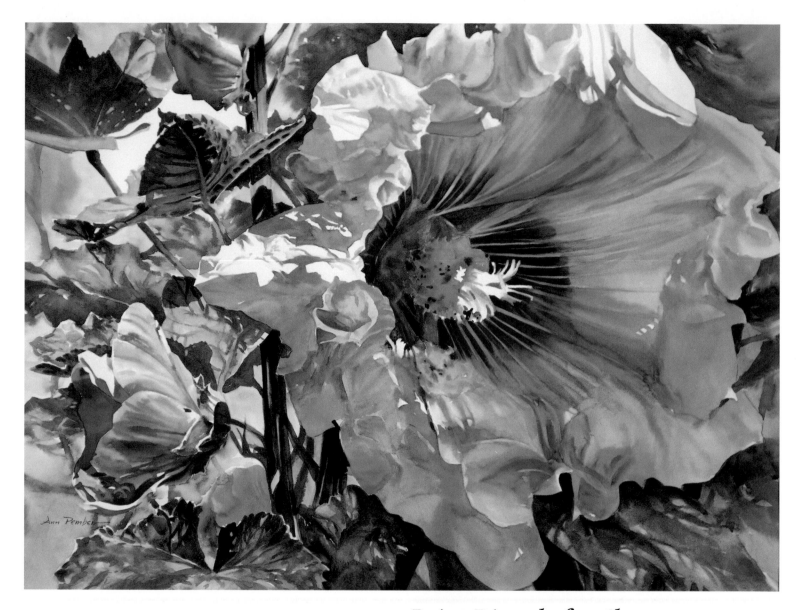

Paint Directly for Clean, Luminous Color

ANN PEMBER

As always, I tried to achieve the correct color intensity with the first application of paint. This produces the cleanest, most beautiful color, with wonderful luminosity. As I wet an area, I let colors mix on the paper, changing hue and temperature with every few strokes. I like to keep some edges soft, painting around whites rather than masking them. **TECHNIQUE:** I prefer to paint with transparent pigments, using staining colors for rich darks. Waterford 140-lb. cold-pressed paper, used here, is a favorite. It allows easy lifting, resists buckling and produces beautiful washes. My basic palette is fairly limited. I use Winsor & Newton New Gamboge, Raw Umber, Raw Sienna, Permanent Alizarin, Permanent Rose, Antwerp Blue, French Ultramarine, Cobalt Blue, Viridian and Cadmium Red Purple. I like to mix all greens and never use Viridian alone.

HEAVENLY HOLLYHOCK
Ann Pember, 21½" × 29" (54.6cm × 73.7cm)

Explore New Color Schemes

ONG KIM SENG

I often like to explore new subjects for my watercolors. I also like to explore new ways to apply my colors, so each painting has a different color scheme. The buildings in this scene were a bit cluttered so I selected the cathedral tower with the dome to be the focal point. **TECHNIQUE:** My colors for the focal point are warm, a mix of Chrome Orange with Scarlet Red against a background of cool colors. The background is painted with a very light Hooker's Green mixed with Aquapasto to give a sense of distance. This helps to bring out the main subject.

PORTOFINO, ITALY
Ong Kim Seng, 22" × 31" (55.9cm × 78.7cm)

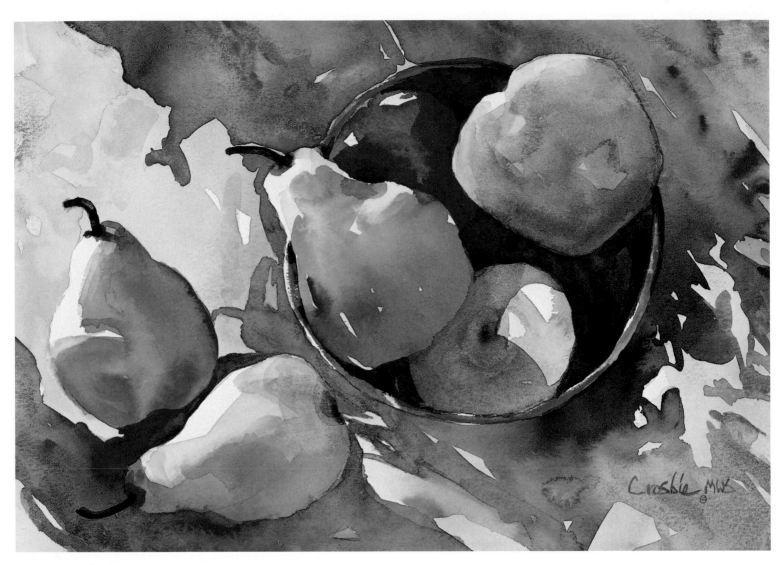

Colors That Look Good Enough to Eat

SHARON CROSBIE

Fresh, clean colors create a sense of liveliness. Flowers and fruit should have that "just picked" look to cause the viewer to want to touch them. All of the colors used here (the whole spectrum) were mixed on paper. Even the shadow colors are vibrant, and generally cooler than the fruit to let them recede. **TECHNIQUE:** After considering the overall design and arranging blocks of color, my task was to make the fruit look juicy and delectable. The wet and delicious look was achieved by painting with immediacy. Once the light value underpainting was dry, I painted each piece of fruit to completion, letting some of these colors bleed into what would later be darker shadows around the fruit. I especially like to use combinations of New Gamboge with Permanent Rose for the yellow to orange colors.

AN ACQUIRED TASTE
Sharon Crosbie, 9" × 13" (22.9cm × 33cm)

Bright Colors Denote Happiness

DELOYHT-ARENDT

Color seems to have universal symbolism: blue is peace, white is purity and so on. Lots of bright color seems to denote happiness. I saw this set up at an outdoor landscape show. The vivid colors of the needlework, along with the pots of flowers, looked inviting and festive. **TECHNIQUE:** To accentuate the brightness of color, I used Crescent 1610 rag board, which is very white. The semismooth surface allows both crisp and soft edges, puddles and drips, which I enjoy. The negative painting and the unpainted white areas give a sense of delicacy to contrast the bold chair and colors. I use Schmincke paints because of their brightness, ability to intermix and their consistency.

MIXED CULTURES
DeLoyht-Arendt, 23" × 14" (58.4cm × 35.6cm)

Experiment With Ideas of Fantasy

JOSEPH MELANÇON

For years I have been captivated by the simple form of old-fashioned tops, as evidenced by my extensive collection of them. This collection has developed into an ongoing painting series. My paintings are often derived from abstract ideas of fantasy events—these tops are portrayed as air ships engaged in some unknown night maneuver over the lake near my house. I use brilliant colors in the beginning as they can always be toned down if necessary. Multiple weak color glazes are laid over to achieve richness and depth. I especially try to maintain color in shadows, which keeps the painting alive. **TECHNIQUE:** I sprinkled clear water on the dry painted surface and rubbed briskly with a clean, dry terry towel to lift color. Over these lightened spots I laid on subsequent color glazes. Bright highlighted edges were achieved with an airbrush. All my colors are nonstaining, which can be easily lifted.

TOP MANEUVERS
Joseph Melançon, 22" × 30" (55.9cm × 76.2cm)

Old Paintings Can Spark New Energy

SYBIL MOSCHETTI

Unsuccessful, unloved watercolor paintings, when torn and collaged on a new base, provide a spark of energy and the beginning of a new, experimental work. Collage is insurance against boredom, since an unexpected direction, shape, line or color can touch off the impetus for adventure. **TECHNIQUE:** Only use collage pieces that are color-permanent and resistant to fading. Ironing and applying weights can smooth ripples or unevenness. For glue, I use acrylic gel medium, which is permanent, durable and reliable.

BLUE PROPULSION
Sybil Moschetti, 38" × 30" (96.5cm × 76.2cm)

Contrast Stark White and Pure Colors

FRANK FRANCESE

On a recent trip to northern Italy, I was very impressed with the colorful contrasts of the cities. In this painting, my goal was to capture the brilliant contrast of clear blue sky and red-orange tile roofs. These pure colors were applied on a dry surface and allowed to mix on the paper. The stark white of the buildings accentuates the color contrasts, resulting in the focal point of the painting. **TECHNIQUE:** The subtle shades in the dark, narrow streets help direct the viewer's eye to the brilliant whites and colors of the buildings, the center of interest. For a sense of scale, I left a few areas of white on the lower part of the painting, depicting the shapes of automobiles and movement of people. Pure cadmium colors were painted over the dark grays to indicate the colorful clothing of the Italians.

VALENZIA, ITALY
Frank Francese, 22" x 30" (55.9cm x 76.2cm)

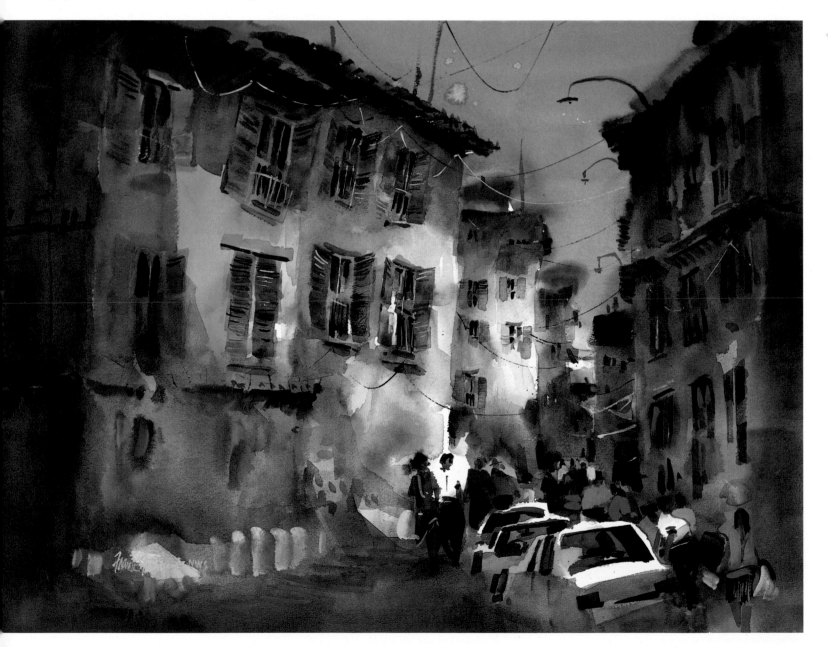

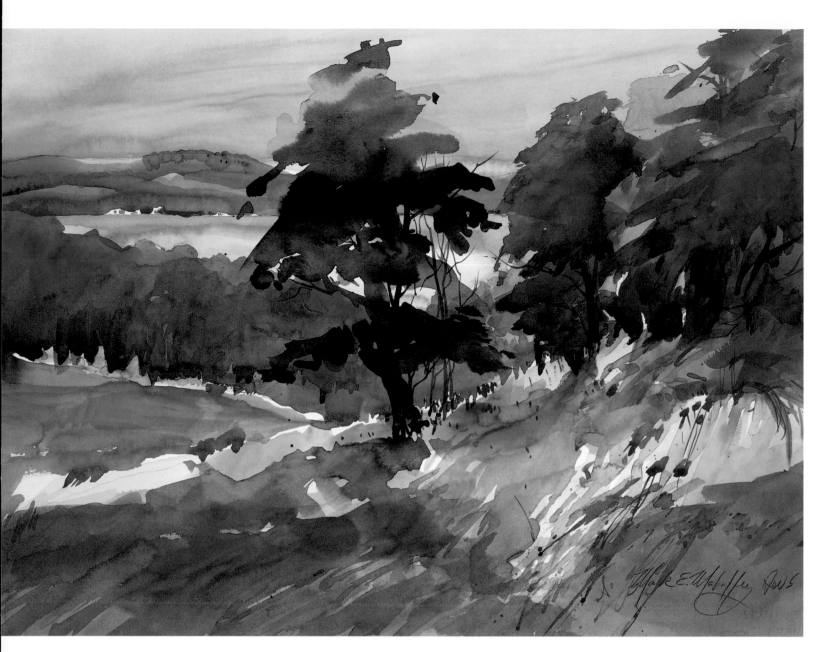

ABOVE THE BAY
Mark E. Mehaffey, 22" × 30" (55.9cm × 76.2cm)

Never Be Afraid to Change Local Color

MARK E. MEHAFFEY

On this warm, muggy morning, the hills above Harbor Springs were dominated by the many greens of summer. I chose to start *Above the Bay* with warm colors; yellows, oranges and reds dominate the sky and foreground and most of the beginning washes. I changed the cool, local colors to saturated warm colors in an effort to capture the feeling of a warm, muggy, summer day. Also, I felt the strong, cool shadows would be more dramatic contrasted against warm colors in the sky and foreground. A painter should never be afraid to change local color. Personal color choice is one more avenue a painter has to communicate with the viewer.

TECHNIQUE: I often use hot-press paper for my outdoor painting sessions. The paint sits up on the surface and allows me to manipulate both texture and color to a greater degree and for a longer time period than working on rough or cold-press paper.

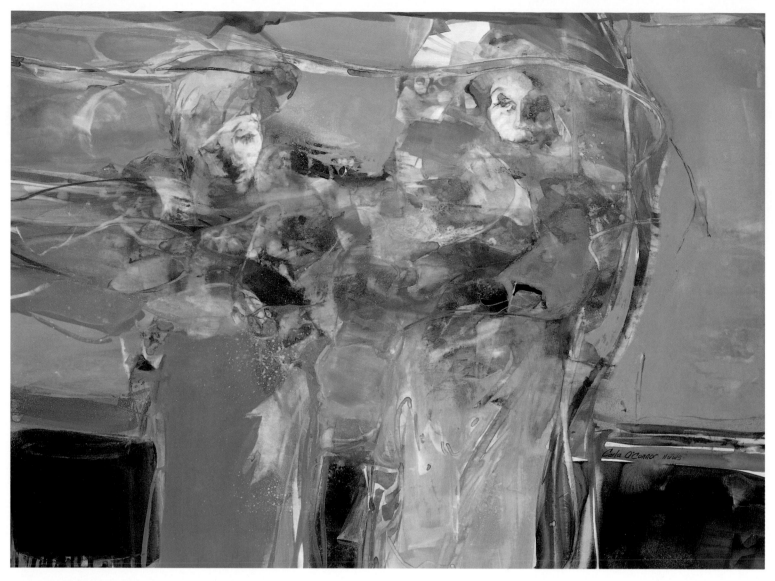

Don't Be Afraid to Change Everything

CARLA O'CONNOR

This painting actually began as a landscape in a warm palette—lots of reds, oranges, yellows and golds. However, almost from the beginning the painting was a struggle with one problem after another. Finally, in frustration, I instinctively reached for the complementary color blue. I began applying large amounts of pigment and changed the piece entirely—from a warm to a cool palette and from landscape to figurative image. Wow! Now it was fun again! By placing complementary colors side-by-side, each appeared brighter and more vivid, intensifying the effect. This color "discovery" led to a series of dramatic figure works in which complementary color was a major factor. *Secrets* became the first of this series. **TECHNIQUE:** The dominant blue was painted over the warm underpainting. This allowed the colors to mix on the surface as the painting progressed. I then lifted out certain areas (such as the ribbons or bands) and finished off with almost black accents.

SECRETS
Carla O'Connor, 30" × 40" (76.2cm × 101.6cm)

Let Your Imagination Take Over

SUSAN HERRON

What grabs me is an exciting pattern. Once I'm satisfied with my composition, I can let my imagination take over when it comes to applying color. Warm against cool, glowing transparency, the thrill of spontaneous color with direct brushstrokes—these are what make painting so enjoyable. **TECHNIQUE:** *The Conductor* was painted on Strathmore Aquarius II paper coated with acrylic gloss medium. I used acrylic paints, transparently, first with a warm abstract underpainting. I lifted a few highlights with rubbing alcohol. The dark background and color accents were then added with direct painting.

THE CONDUCTOR
Susan Herron, 18¾" × 12¾" (47.6cm × 32.4cm)

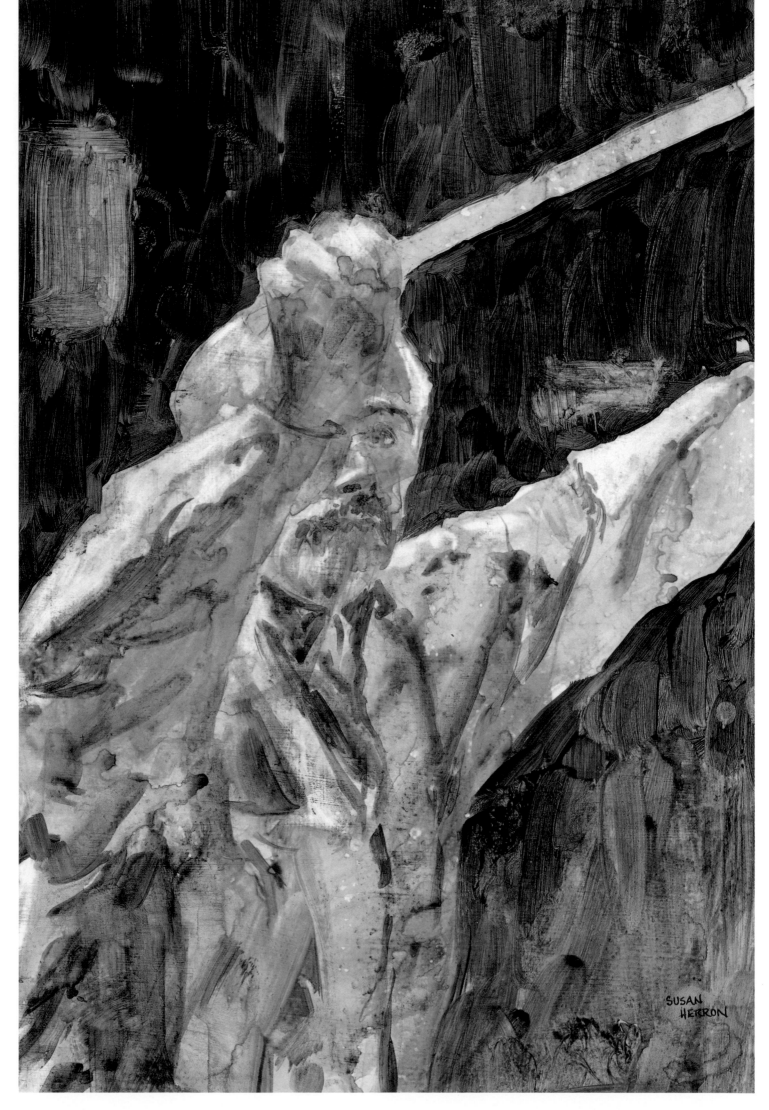

Have Fun, Work Quickly and Use a Wide Brush

SIDNEY MOXHAM

Spontaneity and color are what make my paintings fun. I work quickly and ruin many…the fun part is when the whole thing comes together. **TECHNIQUE:** I use Golden fluid acrylics mixed with whatever is nearby, such as pastel, ink, crayon, alcohol, etc. After blocking out what I want to save with frisket, I splash color on with a wide brush.

KOKOPELLI'S SONG
Sidney Moxham, 30" × 30"
(76.2cm × 76.2cm)

VINE RIPENED
Sheryl Miller Thornton, 10" × 14" (25.4cm × 35.6cm)

Watch Your Colors Mingle, Merge and Drip

SHERYL MILLER THORNTON

I love bold, fresh color. For me, the joy in creating a watercolor painting comes from watching colors mingle, merge, drip or separate in glorious and often unexpected ways. Working on dampened paper and mixing colors directly on the paper, rather than on the palette, encourages spontaneity. While painting *Vine Ripened*, the paint began to drip, at which point I gently tilted and manipulated the painting to encourage what was happening naturally. I have gained a respect for what the water and pigment can do on their own and try to maintain an open-minded approach. **TECHNIQUE:** Generally, my paintings are done in one session using 140-lb. rough paper that has been thoroughly saturated with water. After initial washes, and as the paper dries, I use more pigment and less water to define certain areas. The final step is detail and calligraphy. I try to paint with minimal, assertive brushstrokes and never use anything smaller than a no. 14 round brush. This helps keep a looseness in my brushwork that I desire.

Choose a Limited Palette of Pure Hues

CONGRATULATIONS
Jean K. Gill, 22" × 30" (55.9cm × 76.2cm)

JEAN K. GILL

I wanted the subject to burst off the page in an exuberant, celebratory mood, so I took artistic license, exaggerating colors and contrasts to maximize drama and excitement. I avoided muted colors, mixing neutrals, or using unsaturated tube colors and focused, instead, on pure hues, their tints and the white of the paper. My favorite hues are those that are lightfast and transparent with high tinting strength.

TECHNIQUE: For each work, I select a limited palette of five to nine paints. Since I always have multiple works in progress, I keep a record of colors used in each. This allows me to move from one piece to another without introducing new, potentially dissonant colors. *Congratulations* features one violet and two versions of each primary color. I painted directly without masking; the bow and small light flowers were created by painting their negative space.

FIELDS OF GOLD
Catherine Anderson, 22" × 30" (55.9cm × 76.2cm)

Attack a Dull Start Fearlessly

CATHERINE ANDERSON

It was my first mustard season since I moved to the Napa Valley, where mustard grows throughout the vineyards in the valley. It is spellbinding; the colors are brilliant! I had started *Fields of Gold* and lost interest, leaving it half finished. I had at least one hundred washes of colors in the sky and mountains, while the rest of the paper was still white. It was dreadful-looking, and I was lost. "Okay, just put in trees and see what happens," I thought. "What do you have to lose?" I painted the trees in, and immediately things began relating. "Now do the mustard!" With bold abandon, the yellow paint went on. It was love at first sight! After pushing myself to attack a boring painting fearlessly, *Fields of Gold* became one of those paintings I never wanted to end; I had so much fun working on it. Never give up!

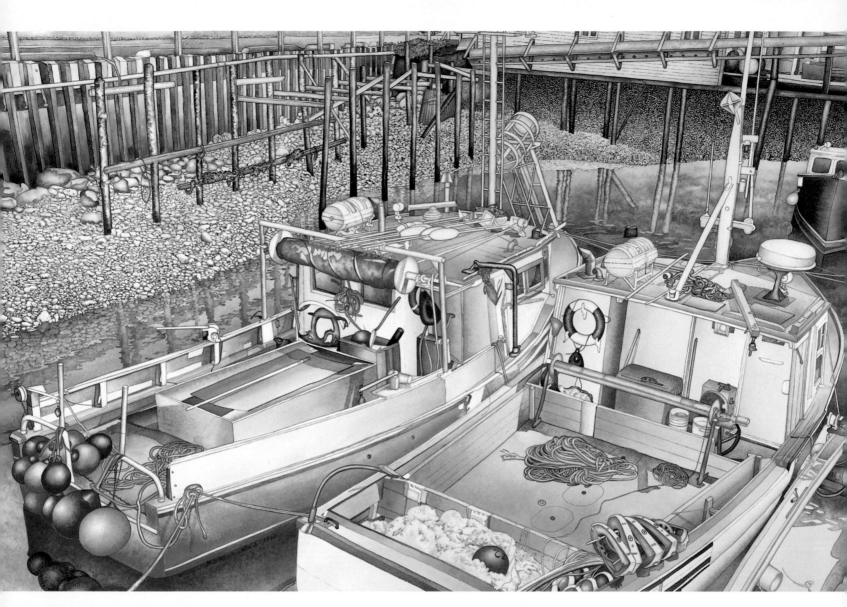

Invent New Colors Daily

MISSIE DICKENS

The boats are such an odd color that I titled the painting from a line in a children's poem, "The Owl and the Pussycat went to sea in a beautiful pea-green boat." I find great joy and excitement selecting colors; each day my palette differs. I can't remember from day to day how I mixed my colors, and I don't care to. My invention of colors is arbitrary and intuitive, chosen by instinct and fun. I "see" the finished painting in all its Fauve intensity before I begin. **TECHNIQUE:** I use Arches hot-press paper because color appears brighter sitting on top of its hard surface. Some of my favorite paints are Winsor & Newton Winsor Emerald and Cobalt Violet watercolors, Liquitex Permanent Light Blue acrylic and Lefrance and Bourgeois gouaches, especially their pinks. I use a 3-0 size brush for outline details.

THE OWL AND THE PUSSYCAT
Missie Dickens, 22" × 30" (55.9cm × 76.2cm)

Discover Reflected Color

K. JODI GEAR DVM

It's easy to paint the local color of a subject. The excitement comes in discovering color that is reflected from the environment. Look closely for color in the shadows, especially in the shadows of a white surface. It is the amplification of these subtle colors that takes a painting beyond the ordinary. **TECHNIQUE:** I used Miskit to preserve the very light areas, removing and reapplying it several times as the painting progressed. In general, I do not mix the colors on my palette, but prefer to layer them in many glazes on the paper. I feel this gives the painting more depth and keeps the colors vibrant.

FETLOCK
K. Jodi Gear DVM, 13" × 9½" (33cm × 24.1cm)

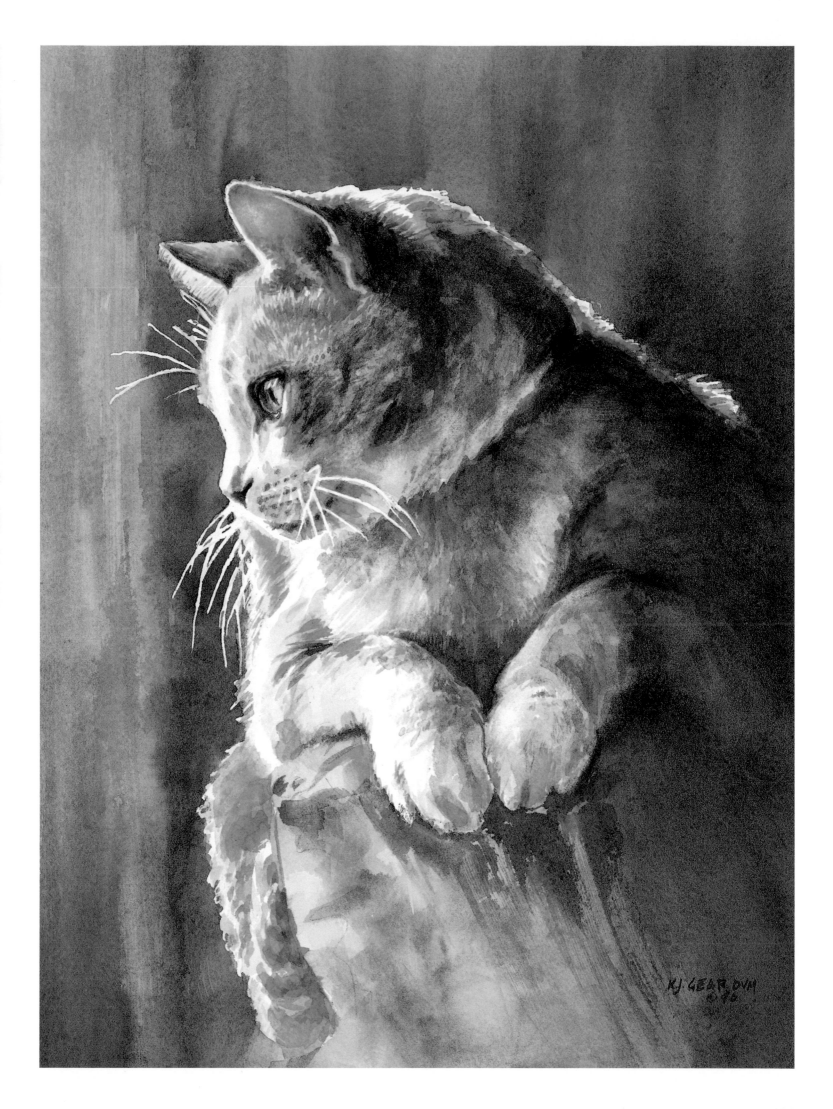

SEPTEMBER LIGHTS
J. Luray Schaffner
30" × 20" (76.2cm × 50.8cm)

Create Vibration With Hues of the Same Value

J. LURAY SCHAFFNER

The intensity of color hues of similar value, along with the use of texture, creates a torch of color with waves of light creating a visual line. The repetitive dot pattern balances the harmony of color.

TECHNIQUE: I paint directly onto a four-ply cold-pressed museum board using an angular shader, wedge ferrule and a script liner brush. I then introduce hand-painted papers, silkscreen fragments with a white translucent wash and color-saturated rice paper. An airbrush softens or fades out certain areas.

Four Essential Colors for Deep Darks

HEIDE E. PRESSE

The Mending Basket was almost completely painted with the four colors I cannot do without: Prussian Blue, Raw Sienna, Burnt Sienna and Cobalt Violet. With these pigments, I can make the deepest darks and a wide variety of colors that are a basis for my shadows. **TECHNIQUE:** I first masked out the upper portion of the body and the basket so I could loosely wash in the background. After removing the mask, I slowly built up the color intensity with multiple glazes. I finished up the details using drybrush. While most of my light areas are the white of the paper, I will use Titanium White casein for complex and tiny details, and for mixing with the other watercolors to add body.

THE MENDING BASKET
Heide E. Presse, 26½" × 15" (67.3cm × 38.1cm)

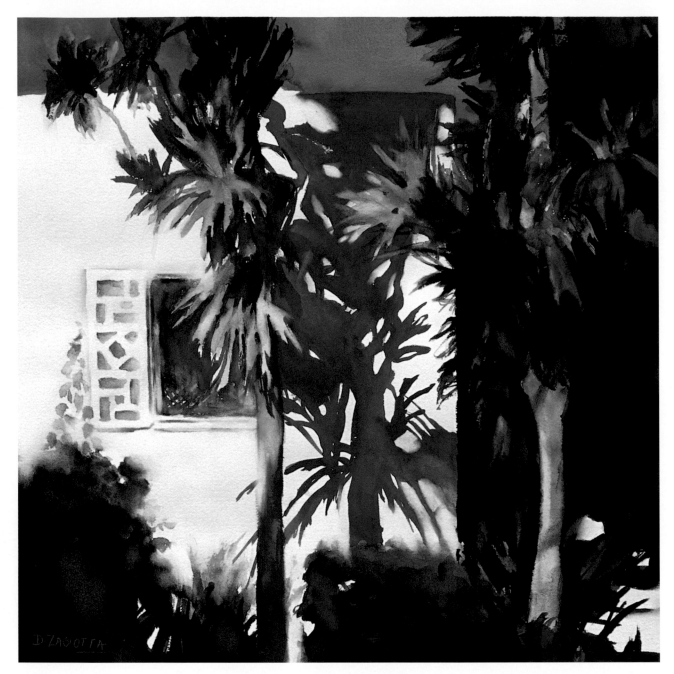

"Outrageous" Color for a Natural Effect

DONNA ZAGOTTA

CARMEL PALMS
Donna Zagotta
17" × 17" (43.2cm × 43.2cm)

In *Carmel Palms*, the delightful shadow pattern on the brightly lit white stucco wall captured my interest. The colors in my reference photo were quite dull and color-less, so I decided to exaggerate them. This painting is part of a series where my concept included "outrageous color." The colors in my paintings had become too predictable and ordinary and I was searching for brighter, more expressive color. The paintings in this series had (or so I thought) overly bright, unnatural, "pushed" color. But looking at *Carmel Palms* now, the color doesn't look strange or outra-geous to me at all, but quite normal and natural. What I learned is that in the process of exaggerating, the end result is quite natural and really what I wanted to express anyway. **TECHNIQUE:** To create rich, bold and colorful darks in watercolor, it is necessary to have dark-value colors on your palette. Cerulean Blue and Cobalt Blue, for example, are middle-value blues that are useful for mixing light- and middle-value colors, but are not capable of mixing darks. However, Peacock Blue or Winsor Blue, when mixed with dark reds and yellows, will create beautiful warm and cool darks that approach black.

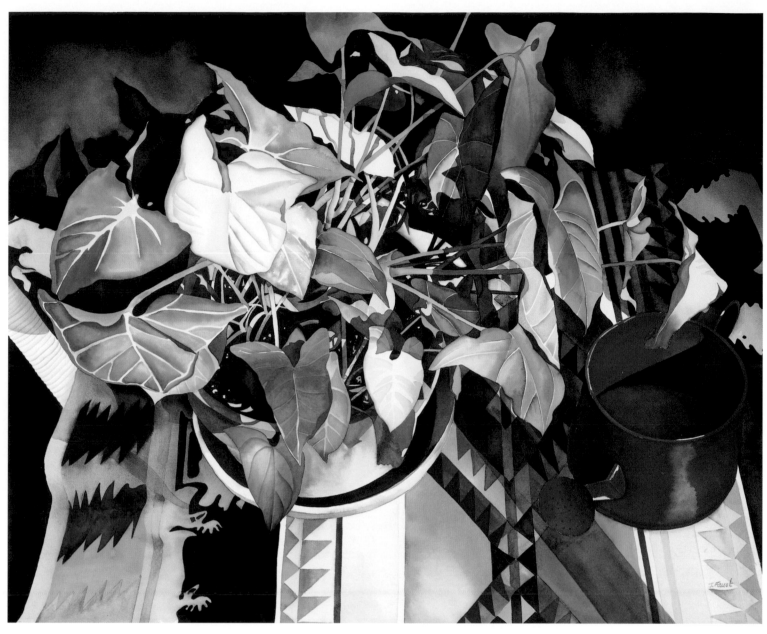

CALADIUMS
Jennifer Moore Faust, 20" × 29" (50.8cm × 73.7cm)

Sunlight + Bold Colors = Spectacular

JENNIFER MOORE FAUST

Bold colors juxtaposed with cool shadows and bright sunlight are irresistible. One spring afternoon I noticed this red watering pitcher next to a pot of caladiums. The sunlight was sparkling through the trees and I knew that I had to paint it. My style is somewhat realistic; however, I like to keep the shapes of objects fluid and transparent. I don't want to show every vein in a leaf or thread in the rug, just the moment as I experienced it. **TECHNIQUE:** I don't have any set rituals; I use whatever is in front of me and paint just what I see. *Caladiums* is painted on Arches 300-lb. hot-press paper, using Winsor & Newton paints.

Set the Stage With

COLORFUL SUBJECTS *or* BACKGROUNDS

Some subjects, because of their unusual or intense local color, call for special treatment. In the words of a famous film, they make you an offer you can't refuse, easily becoming the focal point of the painting. In other cases in this section, backgrounds call for special treatment, often to enhance the subject, but sometimes because they are interesting in themselves.

I love to travel to places that offer distinctive and interesting architecture. Belém Tower in Lisbon, Portugal, is such a place. Built in the seventeenth century, it's a fort made of white limestone, commanding a stunning view of Lisbon harbor. Because of its brilliant whiteness, I decided to paint it against a dark blue sky. After doing the drawing, I masked out the tower mass and proceeded to apply a light wash of Alizarin Crimson over the entire sky area. After this dried, I laid in four separate washes of Ultramarine Blue and Cerulean Blue with a dash of Sepia added to reduce the intensity of blue. This gave me the color and value I needed to bring out the lightness of the tower.

—RANULPH BYE

BELÉM TOWER, LISBON, PORTUGAL
Ranulph Bye, 20½" × 28½" (52.1cm × 72.4cm)

Capturing Brilliant Shadow Colors

HAY WAGON
Nina Allen Freeman, 11" × 14" (27.9cm × 35.6cm)

NINA ALLEN FREEMAN

In *Hay Wagon* I painted my first impression of the brilliant colors I saw in the shadow side of this wagon piled high with hay. The few strands in light took on the appearance of spun gold. I chose to allow saturated colors to flow into one another on the wet paper in the shadow section, making the light colors "pop" by contrast. **TECHNIQUE:** Masking was used in the initial stages of the painting. A limited selection of primary colors were used and allowed to blend on wet paper. This creates interesting color effects that cannot be achieved when mixing on the palette. Carefully placed darkest darks were painted last with Payne's Gray.

Make Silver Glow With Reflected Color

VEGETABLE FIESTA
Dawn McLeod Heim, 14" × 16" (35.6cm × 40.6cm)

DAWN MCLEOD HEIM

When I was almost finished with my painting, my twelve-year-old son walked up and said, "Wow, Mom, that looks like real silver!" He paused for a moment, then said, "But I know it's paper!" To me that said it all. I didn't create the illusion of silver by using a tube of silver paint, but achieved it by using color, primarily reflective color from the surrounding objects. I use transparent colors to establish a glowing underpainting, then begin to layer color until I get the deep, rich tones I want. I use the opaque watercolors, such as the cadmiums, for glazing. For color harmony, I mix grays from colors already established in my painting. **TECHNIQUE:** To keep the place mat from competing with the glow of the vegetables and silver, I slightly grayed the colors down. After painting the large shadow on the right, I painted each horizontal and vertical loop separately, lightly tissue-blotting each one to create texture.

Subject in Neutrals, Complementary Background

KAREN FREY

This painting focuses on the complements green and red. The main color is green, seen throughout the background in subtle, neutralized tones. This enhances the purer saturation of the smaller red areas. I rendered the bird's form with neutral grays so as not to distract from the general color contrast, drawing attention to the bird through value contrast. **TECHNIQUE:** Some of the newer, synthetic reds now available are really vivid, and they don't deaden as they dry. I always mix my own greens, and include only one premixed green in my palette, Thalo or Winsor, in order to mix the blacks.

FRANK AND CONG
Karen Frey, 14" × 20" (35.6cm × 50.8cm)

Push and Pull Your Background to Make the Composition Work

SUSAN KATHLEEN BLACK

I love bright, vibrant colors, so roses are great fun to paint. As I added more and more color to the *Color of Roses*, the painting seemed to take off on its own. As I painted the background, I kept checking to see where I needed more color to make something really pop out, or where I needed to blend the background into a flower in order to push it back. It was a constant push and pull until it worked as a whole composition. **TECHNIQUE:** In order to achieve the vibrant reds, as well as the dark background areas, I use lots of pigment fresh from the tube and lots of clean water. Working wet-into-wet, I usually let the colors mix on the paper.

COLOR OF ROSES
Susan Kathleen Black, 37" × 29" (94cm × 73.7cm)

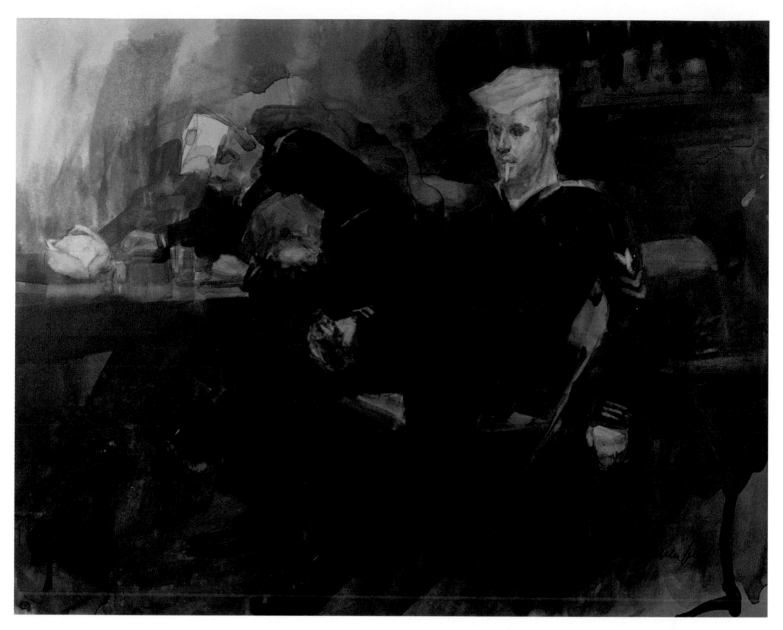

Keep Background Elements Muted

IRWIN GREENBERG

One of my watercolor students, newly discharged from the navy, posed for us in uniform. The strong dark/light contrast on the figure, plus a little warm tone on the face, suggested that I use a middle value for the background. I lay in the setting with warm and cool grays, and, remembering my own military past, decided to indicate a couple more sailors done in by inebriation. These figures, and the other background elements, are muted so that the primary focus (the foreground sailor) projects clearly. **TECHNIQUE:** I work on plate-finish bristol board. From this smooth surface, color may be lifted out partially or clear back to the white of the paper. I use a fairly stiff-bristled acrylic brush to lift out tone.

THREE SAILORS
Irwin Greenberg, 11" × 14" (27.9cm × 35.6cm)

Don't Ignore a Colorful Subject

BETH PATTERSON TOONI

I found this colorful subject while visiting Nantucket. When I first walked by the cozy restaurant, the outdoor tables were crowded with people. The following day I returned with my camera, delighted to find this inviting scene. What had attracted me was the vibrant red of the table and chairs, but now I had the added bonus of the wonderful cast shadows with their fabulous colors and shapes. **TECHNIQUE:** I began with a careful drawing of the complicated ellipses of the table tops and chair seats and the tricky perspective of the brick floor. I painted in layers with a simple palette—a warm and a cool of each primary, plus Burnt Sienna. Even the black of the ashtray was made with heavy, saturated blues and browns.

TABLE FOR TWO
Beth Patterson Tooni, 26¼" × 18¼" (66.7cm × 46.4cm)

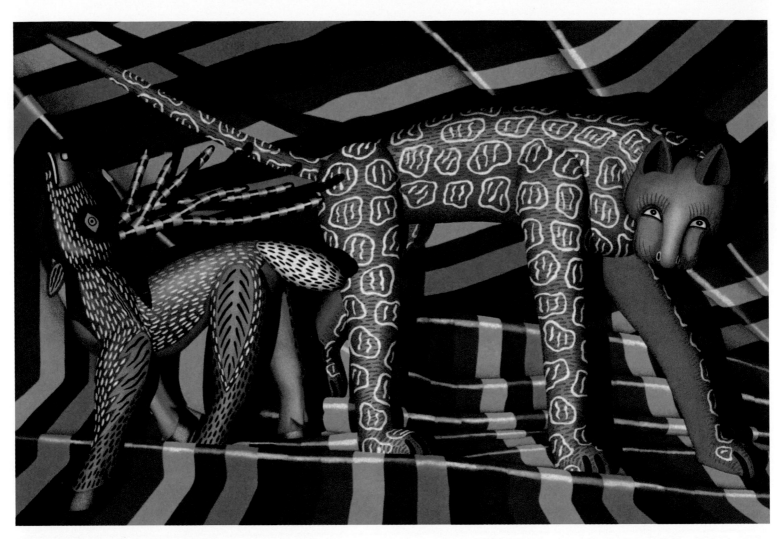

Brightly Striped Background Represents Sunset

JERRY W. BOWMAN

The background of a painting is often more crucial to overall success than the focal items. In *Oaxacan Sunset* I have used a strongly colored, flowing cloth to represent the sunset sky. The intense yellow stripe imparts a strong sense of dynamic flow and direction. I collect these superb wood carvings from Oaxaca, Mexico, and often include them in my paintings. These and other icons populate my work and are intimately tied to my love of color and pattern. **TECHNIQUE:** Real objects are easier to paint than imaginary ones. While much of the color and pattern in my paintings are my own creation, the physical elements are always based on actual objects. Here, the original drab background cloth was given drama and dynamism by creating brightly colored flowing stripes.

OAXACAN SUNSET
Jerry W. Bowman, 32" X 48" (81.3cm X 121.9cm)

Exact Opposites Create Maximum Energy

MARY LOU FERBERT

The starting point of the painting was the gondola car with its rich patina of rust. The ground-level perspective adds drama to the car and the sunflower, a frequent companion of railcars in the Midwest. Occasionally we experience a clear, blue sky over a steel mill, and what an exciting foil for the streaked body of the railcar and the wildflower. **TECHNIQUE:** The sky is a cool blue, so I moved directly across the color wheel to the red-oranges for the color in the car and plant. Exact opposites on the color wheel create maximum drama and energy.

SUNFLOWER AND GONDOLA CAR
Mary Lou Ferbert, 39⅛" X 24" (99.4cm X 61cm)

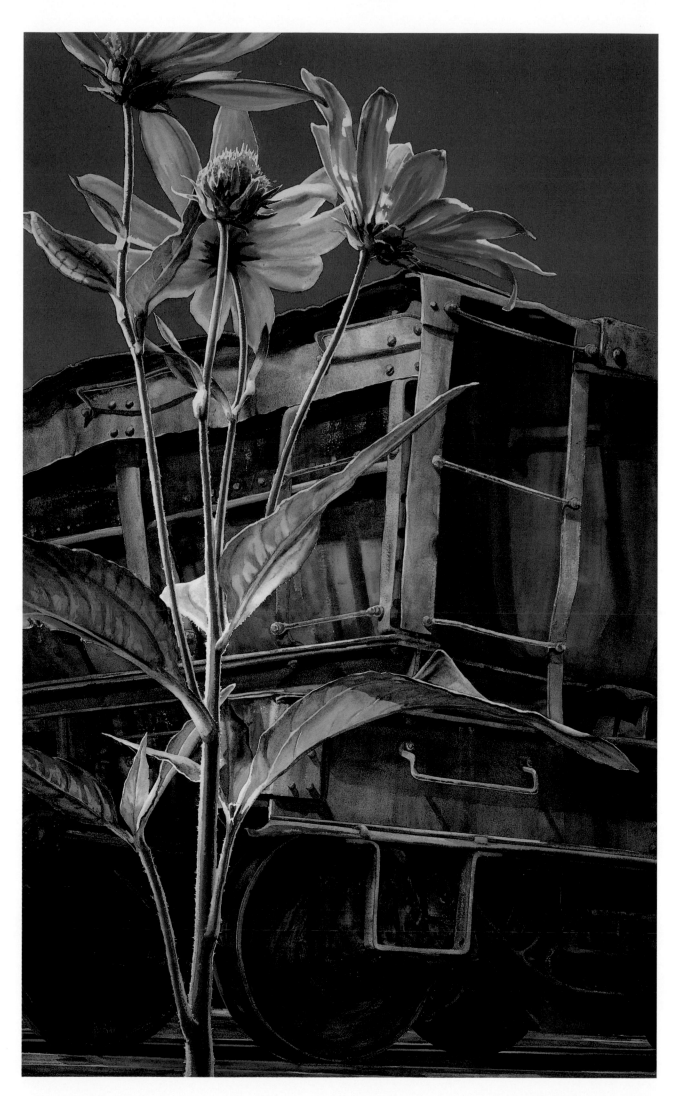

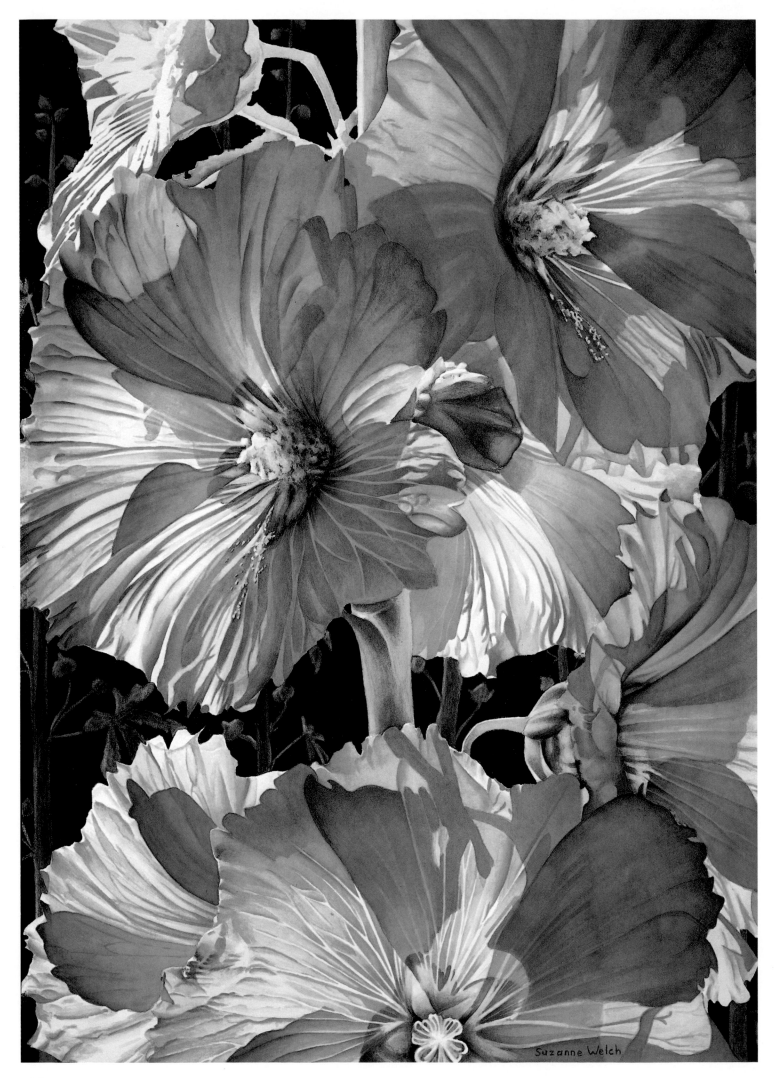

Suzanne Welch

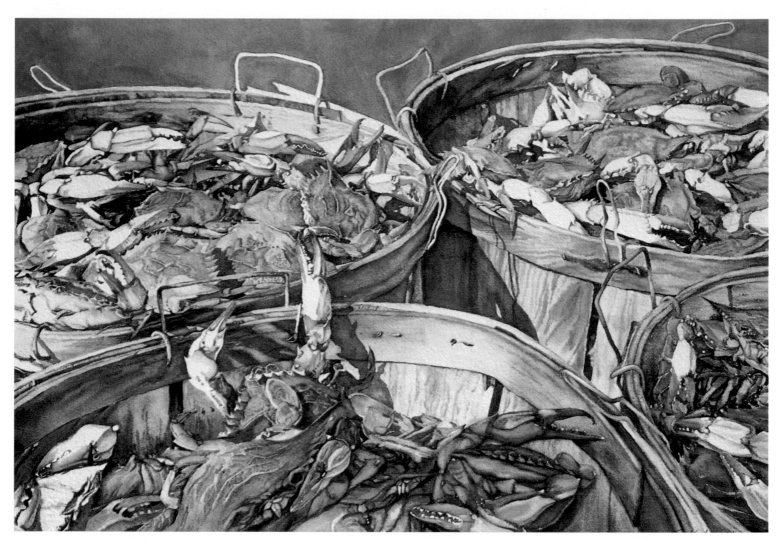

Nature Provides Wonderful Subtleties

ELAINE HAHN

Upon close observation of subjects from nature, I am continually amazed by how an area that may have appeared one color will actually have so many different color variations. *Crabs a Plenty* is a subject close to the heart of those on the eastern seaboard. I was drawn to the subject because of fond memories, but also found myself mesmerized by the many subtle colors and shapes of a blue crab. **TECHNIQUE:** In this painting, there were beautiful colors to find in every shape. I work with a limited palette of a cool and warm of each primary color, plus Raw Sienna, Warm Sienna and Thalo Green.

CRABS A PLENTY
Elaine Hahn, 15" × 22" (38.1cm × 55.9cm)

Deep Black Heightens Petals' Translucence

SUZANNE WELCH

I like to crop, changing the viewpoint by closing in on the subject. This emphasizes structure, pattern and details. I start with a detailed underpainting and then use many layers of glazes. **TECHNIQUE:** Before putting paint on paper, I refer to color charts I've made (small squares showing every color mixed with each of my other colors). These charts give the benefit of some delightfully surprising results, such as the velvety purple-black of the background in *Seven Sisters*, a mixture of Cadmium Red Purple with Ultramarine Blue.

SEVEN SISTERS
Suzanne Welch, 28" × 20" (71.1cm × 50.8cm)

Simple White Shapes Against a Colorful Background

RUTH COBB

I am interested in the brilliance of simple white shapes against a strongly colorful background, inspired by Persian miniatures. The whites become almost sculptural in contrast to the rich vibrations set up by the juxtaposition of primary colors, thereby creating a feeling of energy. **TECHNIQUE:** The painting was done entirely with transparent washes. The white flowers were first blocked out with Miskit so that the color could be worked around them freely. After the background was completed, the Miskit was rubbed off and some delicate tones added to the flowers. Then the other details, like the leaves, were painted directly.

CHRYSANTHEMUMS
Ruth Cobb, 21½" × 29½" (54.6cm × 74.9cm)

Bring White Surfaces Alive With a Bright Background

DIANE MAXEY

When I set this little rescued "orphan" pitcher next to a bunch of rust-red daisy chrysanthemums, the white surface came alive. Each plane was beautifully molded and each edge softly sculpted by reflected light. I chose five additional red pigments to expand my existing palette in order to make the color all it could possibly be. I selected pigment colors for their natural variety of value, intensity and temperature. **TECHNIQUE:** Transparent glazes of gradually cooling warm colors accent each plane of the white china as it moves away from the light. Gently lifting the pigment from the Lanaquarelle surface using a Fitch scrub brush produces the sparkles of light.

FROM THE COLLECTION
Diane Maxey, 8" × 6" (20.3cm × 15.2cm)

Increase Color Intensity by Incorporating Empty Space

LOUANNE HEADRICK

The vertical shapes in this horizontal format are made more vivid through the absence of ground color in the background. With the pictorial content simplified, the paper white negative shapes, with softly glowing edges, impart an extraordinary dimension. Complementary colors are hard at work through gradations of yellow-greens to blue-greens, contrasted with shades of plum. Any painting that contains a large percentage of foliage greens needs color variation to maintain overall interest. **TECHNIQUE:** Using a two-brush technique, one loaded with pigment and the other loaded with clear water, I paint with a limited palette of Permanent Rose, Winsor Yellow, Prussian Green and Thalo Yellow Green on Waterford 140-lb. cold-pressed paper. The two-brush process enabled me to grade the color over each leaf segment wet-into-wet. This was time consuming, but conveyed the idea of sun-filled passages.

TROPICAL DAYBREAK
Louanne Headrick, 21¾" × 29" (55.3cm × 73.7cm)

Just the Right Color for Azaleas

ROBERT REYNOLDS

This painting utilizes the full intensity of the color Opera made by Holbein—it's just the right color for pink azaleas. In London I spent a good deal of time in the many public gardens and parks. The blossoming azaleas and rhododendrons were overwhelming and certainly stirred my imagination. The flower forms forced me to use more color than I normally do. **TECHNIQUE:** I was immediately taken by the contrast of the sharp, yellow-greens as they opposed the bright, pink forms of the azaleas in this partially hidden garden stream that most people would pass by without a second glance.

STREAM OF AZALEAS
Robert Reynolds, 37" × 27" (94cm × 68.6cm)

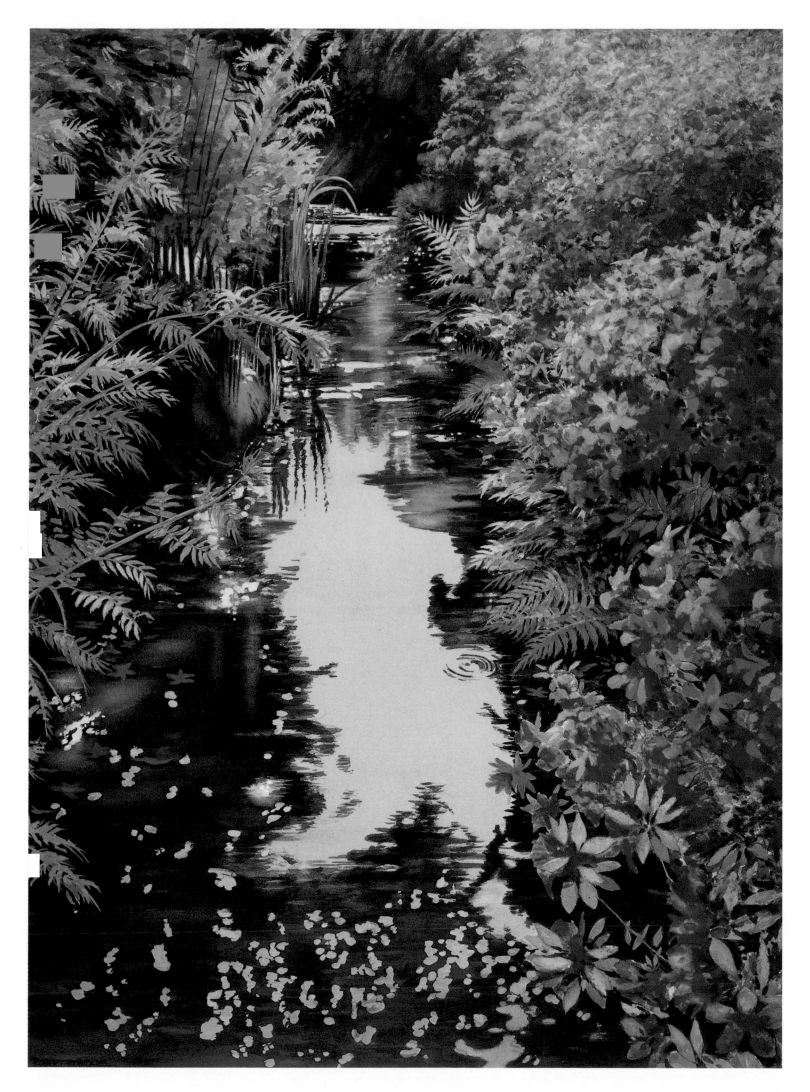

Aqueous Background Interacts With Subject

GOLDFISH 89 NO. 1
Cheng-Khee Chee, 29" x 41" (73.7cm x 104.1cm)

CHENG-KHEE CHEE

Goldfish give people pleasure and relaxation. I have studied them for many years in aquariums, books and magazines and have a good grasp of their physiology and habits. This enables me to take almost an improvisational approach in the process of painting. There are over one hundred varieties of goldfish, but my favorites are the fantail and veiltail varieties because of their beautiful shapes, bright colors and graceful movement. Except for the bright colors, the fish are generally lighter in value than the negative background; and they have soft edges. The saturated wet paper allows easy lifting, gives soft edges and maintains a unified background. In painting fish I try to get the feeling that fish are in the water. **TECHNIQUE:** I thoroughly wet the paper, wiped off surface water and drew a rough outline of the composition with a brush. I painted the negative background first and then lifted shapes of fish off the moist surface. The next step was to build the forms and lay in bright colors. For fish scales, I used the stenciling method. I cut scales of various sizes on a sheet of plastic, lifted out individual scales with a moist sponge and touched up with a brush.

Reveal Colors Hidden in Shadows

CHERRIES
Marlies Merk Najaka, 17" × 18" (43.2cm × 45.7cm)

MARLIES MERK NAJAKA

My objective in this painting was to explore light as it affects transparent and opaque objects. As I paint, I try to reveal the colors hidden in the shadows, creating a heightened reality. The movement and placement of the shadows are an important focus for me because they give the painting a cohesiveness and sense of drama. **TECHNIQUE:** I paint on Arches 300-lb. cold-pressed paper. Some of my favorite watercolor brands are Holbein, LeFranc and Daniel Smith. I use a liquid mask on small highlight areas and allow the colors to mix and blend on the paper, working wet-in-wet.

Red Cabbage Demands Attention

SALLY CAYS

Sometimes the color, light and image of a particular subject take control and demand their own expression. The intense color of the red cabbage leaves riveted my attention. Their enormous size captured my imagination. I remember thinking, "I could use those leaves for a still life without the need for any other drapery." Every other thought and intention left my mind as I found myself picking, pulling, washing and arranging vegetables in the bright midsummer sunlight. **TECHNIQUE:** First I defined the dark areas and shadows in shades of violet, creating a value study. Then I worked each of the separate elements nearly to completion before moving to the next. I rarely use black or gray since the effect I seek to achieve is the energy of light filtered through layers of lively transparent color.

FROM OUR GARDEN
Sally Cays, 22" × 30" (55.9cm × 76.2cm)

The Challenge of Painting White Flowers

NANCY ANN FAZZONE-VOSS

White flowers—leave them completely unpainted and you have a visual hole in your painting. Painted with too many shadows or colors and they look like dirty flowers or other-colored flowers with white highlights. The solution is to include enough of the reflected colors in their shadows to unify them with their sur-roundings, and enough pure white in their petals to retain their own identity as white flowers. **TECHNIQUE:** I start each water-color by painting one of the most interesting or involved areas first. In this painting it was the two gladiolus buds (center right) with the dark shadows moving across them.

I ALWAYS LIKE THE DAISIES
Nancy Ann Fazzone-Voss, 26⅝" × 17¼" (67.6cm × 73.8cm)

RED ROCKET
Don Getz
30" × 22"
(76.2cm × 55.9cm)

An Abstract Background for a Mechanical Subject

DON GETZ

Red Rocket was created by first masking out the highlights of the hot rod engine with liquid mask, then laying on loose washes of transparent reds and blues to create the abstract background. Then, after removing the masking, transparent washes were incorporated into those protected areas. I always create light and dark patterns in my work to establish a focal point. **TECHNIQUE:** I work with a limited palette of one hot color, one cool color and an accent color; in this case, Schmincke's May Green. Nylon brushes suit me fine, as I do lots of scrubouts. I prefer smooth paper as I like to create my textures by painting them.

A Festive Background in a Singular Color Note

BARBARA K. BUER

This painting was inspired by the very colorful Liberty silk scarf my son brought me from London. As the zinnias peaked in early September, they challenged me to put them together with the scarf and prove that a red foreground, middle ground and background could work as a painting. I accentuated the sunlit flowers and copper vase and allowed the sunlight to pour across the foreground, creating strong contrast.

TECHNIQUE: I used six reds and oranges, two yellows, pink, purple, green and black—as many different colors as possible in order to make this single-color-note painting interesting.

SEPTEMBER STILL LIFE
Barbara K. Buer
30" × 22"
(76.2cm × 55.9cm)

LIFT OFF AT DAWN
Arne Lindmark, 22" × 30" (55.9cm × 76.2cm)

For memory has painted

this perfect day

With colors that never fade.

—CARRIE JACOBS BOND

JEAN UHL SPICER, AWS
11 Tenby Rd.
Havertown, PA 19083
pg. 5 *Maize Harvest* © Jean Uhl Spice, collection of the artist
pg. 84 *Autumn Blend* © Jean Uhl Spicer, collection of Charles Cleghorn Co.

TERI STARKWEATHER
7914 Jason Ave.
West Hills, CA 91304
pg. 26 *Geometric Romance* © Teri Starkweather

SHERYL MILLER THORNTON
3503 Millcreek Circle
Salt Lake City, UT 84106
pg. 105 *Vine Ripened* © Sheryl Miller Thornton

BETH PATTERSON TOONI
21 Jensen Ave.
Chelmsford, MA 01824-2247
pg. 120 *Table for Two* © Beth Patterson Tooni

JUDY D. TREMAN
Judy D. Treman Studio/Gallery
1981 Russell Creek Rd.
Walla Walla, WA 99362
pg. 48 *Happy Coat* © Judy D. Treman

LENOX WALLACE
2829 W. 183rd St.
Homewood, IL 60430
pg. 41 *Blossom* © Lenox Wallace

ED WEISS
2121 West Magnolia Blvd.
Burbank, CA 91506
Phone (818) 843-7522
pg. 15 *Candra's Shoes* © Ed Weiss, Heritage Gallery, Camarillo, California

SUZANNE WELCH
1790 Willow St.
San Jose, CA 95125
pg. 124 *Seven Sisters* © Suzanne Welch, collection of the artist

GARY H. WONG
P.O. Box 1522
Monterey Park, CA 91754
pg. 92 *Coral World* © Gary H. Wong, collection of Mandarin Oriental Furniture, Denver, Colorado

DONNA ZAGOTTA
7147 Winding Trail
Brighton, MI 48116
pg. 112 *Carmel Palms* © Donna Zagotta, collection of the artist